IMAGES
of America

HAMDEN

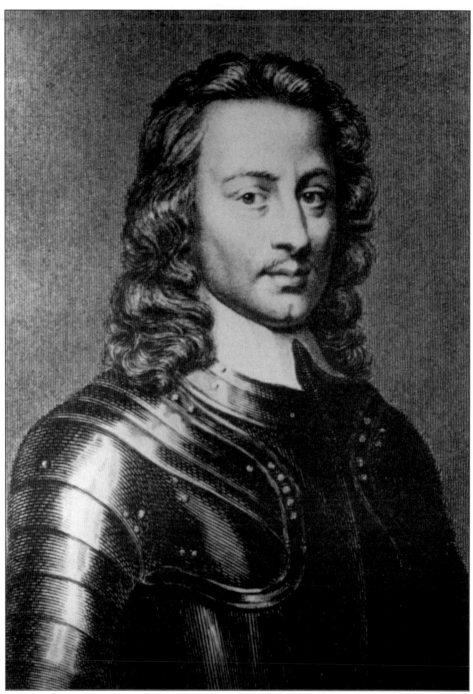

John Hampden (1594–1643), for whom Hamden is named, was an English statesman who opposed arbitrary monarchy and was a cousin to Oliver Cromwell, leader of the Puritan Revolution. Hampden was killed in a battle against royal forces, which earned him a hero's place among descendants of the Puritans in America. Reportedly, Hampden's name was suggested by Hamden representative to the Connecticut General Assembly Amasa Bradley (1762–1827), whose ancestor had been an officer under Cromwell.

IMAGES
of America

HAMDEN

Hamden Historical Society

ARCADIA

Copyright © 2004 by Hamden Historical Society
ISBN 0-7385-3528-1

First published 2004

Published by Arcadia Publishing,
an imprint of Tempus Publishing Inc.
Portsmouth NH, Charleston SC, Chicago,
San Francisco

Printed in Great Britain

Library of Congress Catalog Card Number: 2003116335

For all general information, contact Arcadia Publishing:
Telephone 843-853-2070
Fax 843-853-0044
E-mail sales@arcadiapublishing.com
For customer service and orders:
Toll-free 1-888-313-2665

Visit us on the Internet at www.arcadiapublishing.com

CONTENTS

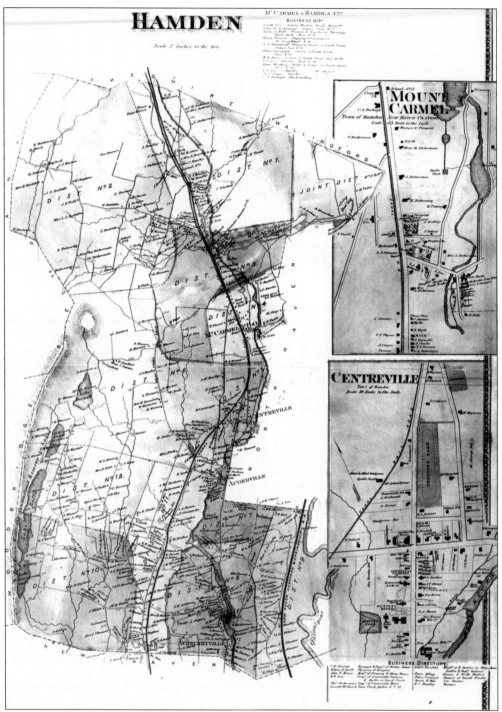

This is a map of Hamden in 1857.

INTRODUCTION

The town of Hamden, Connecticut, has a unique character. From its earliest settlement in the 17th century until its incorporation in 1786, the communities that composed it were a part of New Haven Colony, founded in 1638 by London Puritans. Thus, Hamden's past is very much a part of New Haven's, but it is also distinct. New Haven rapidly urbanized during the 19th century, while outlying areas, including Hamden, maintained a rural character right into the 20th century. Though named in good New England fashion after a 17th-century English reformer who fought with Oliver Cromwell, Hamden is an artificial entity; it has no historic town center, and it lacks the traditional town green, or common. It was created by gathering together a number of agricultural hamlets and small industrial centers, most famously, Eli Whitney's factory village. Efforts to bring the town together and link it to the outside world—for example, the construction in the 1820s of the Farmington Canal, which ran the entire length of the town—at once highlighted the internal struggles for influence, the growing diversity of the town, and the challenges of modernization.

The photographs contained in Images of America: *Hamden* illustrate the rich story of the town's efforts to create a unified identity while confronting the forces of social and economic change, ethnic diversification, and the evolution of town institutions such as schools, civic organizations, and businesses. The illustrations are organized to reflect the separate identity of each discrete section or district within the town and to show how each area contributed to the overall character of the town. Thus, the images range from individual portraits—family patriarchs and matriarchs, young men going to war, or local eccentrics such as the wandering Leatherman—to family groups, both formal and informal; changes in the land, from forest to farmland to suburbia; businesses and institutions; civic organizations, from baseball teams to school classes to police and fire departments; workers, agricultural and industrial, resident and migrant; churches and their members and leaders; and people at play, from skaters on Lake Whitney to hikers in Sleeping Giant State Park.

Through the selection and arrangement of these photographs, the town's evolution from a collection of separate agricultural and rural villages into a modern suburb is illustrated. Although this evolution is common to any number of towns, the experience of each locality is inimitable and fascinating; Hamden's is no exception.

The vast majority of images in this volume are from the collections of the Hamden Historical Society, supplemented by some photographs from the New Haven Colony Historical Society. The communities that make up Hamden were a part of New Haven colony; thus, the history of

Hamden is inextricably bound with that of the parent city. Families from New Haven settled, farmed, and built mills and factories in Hamden and in surrounding towns.

The photographs in the collections of the Hamden Historical Society in Miller Library, numbering in the thousands, span the history of photography, from its advent with daguerreotypes and tintypes dating from the 1840s to the present. This visual essay includes representative images from the antebellum period through the mid-20th century, when the town's evolution from a collection of early industrial villages into a modern suburb was, for the most part, complete.

Photographs in this volume belonging to the Hamden Historical Society were taken from the John Della Vecchia collection, the Raymond Rochford scrapbook collection, the G. H. Welch collection, the Albert Connally scrapbook, the Nancy Sachse papers, and the Rachel Hartley papers. Photograph credits are as follows: Lewis R. Berlepsch, T. S. Bronson, Bernard S. Budge, Myron W. Filley, Peter R. Hvizdak, Leonora Larson, Thomas Pool, Lee Robinson, I. A. Sneiderman, Jay Storm, Arthur J. Teftt, and Fred A. Tyrrell. Some photographs used in this volume were given to the Hamden Historical Society by Lillian Bischoff; Al Gorman; David Johnson; Dr. George Joslin; Miriam, Alice, and Leon Peck; Jane Sibley; Ralph Santoro; and H. B. Welch. We especially pleased to acknowledge the courtesy, cooperation, and generosity of the New Haven Colony Historical Society in granting permission to reproduce some images from its collections.

We would like to thank Martha Becker, Hamden town historian, and Joseph Pepe, archivist of the Hamden Historical Society, for all of their help in assembling photographs and supplying information for the captions. We very much appreciate the careful proofreading of the text by Betsy Gorman, secretary of the Hamden Historical Society.

—Al Gorman, President
Kenneth P. Minkema, Vice President
Hamden Historical Society Inc.

One

WHITNEYVILLE

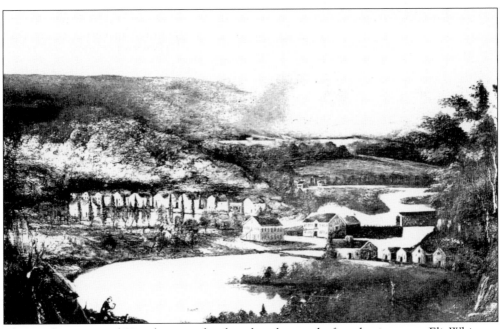

The southern part of Hamden was developed and named after the inventor Eli Whitney, famous for inventing the cotton gin and for applying the system of interchangeable parts to the making of firearms in his Hamden factory. Whitney also owned much of the land along the Cheshire Turnpike (now Whitney Avenue) and over to East Rock. He constructed an early industrial village for the production of muskets for the government, a part of which still exists today at the south end of Lake Whitney and is operated as the Eli Whitney Museum. This painting shows the Whitney works factory buildings and workers' houses along Lake Whitney in 1825.

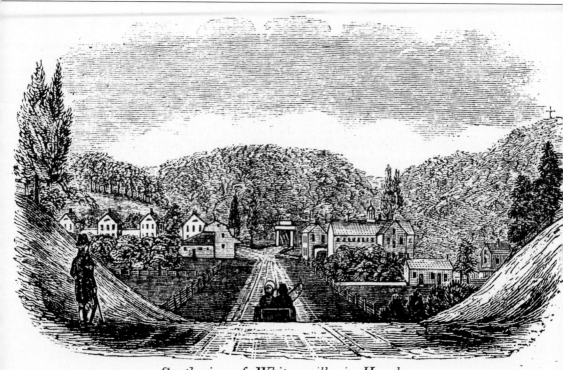

South view of Whitneyville, in Hamden.

Mr. Whitney was born at Westborough, Mass., Dec. 8th, 1765. H was educated at Yale College, and soon after he graduated went in the state of Georgia.

This slightly later *South View of Whitneyville, in Hamden, c.* 1836, is an engraving from John Barber's *Connecticut Historical Collections.*

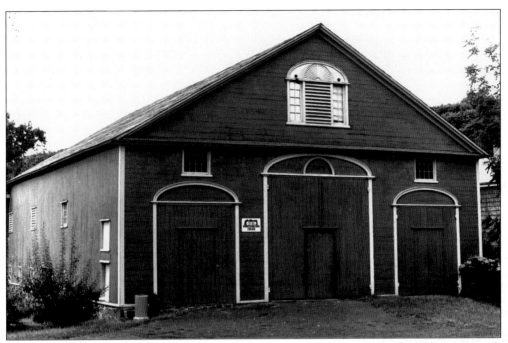

The barn at the Whitney factory, built in 1816, was used for housing and butchering animals and for storing materials.

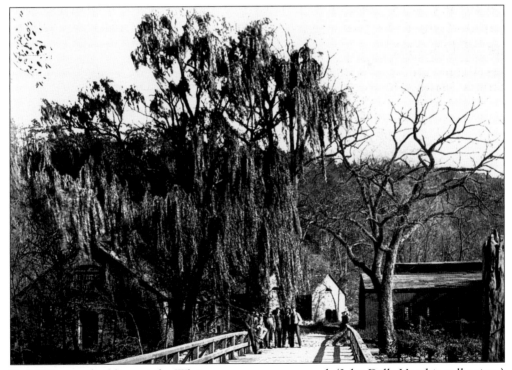

By 1905, many buildings at the Whitney armory were unused. (John Della Vecchia collection.)

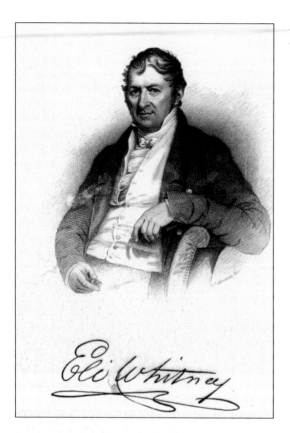

This image shows an etching of Eli Whitney (1765–1825).

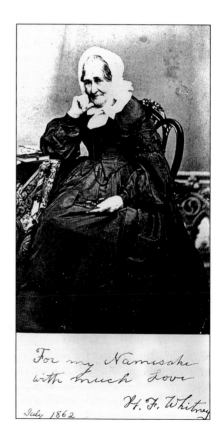

Henrietta Frances Edwards Whitney, pictured in July 1862, was the granddaughter of the famed theologian Jonathan Edwards and the wife and widow of Eli Whitney.

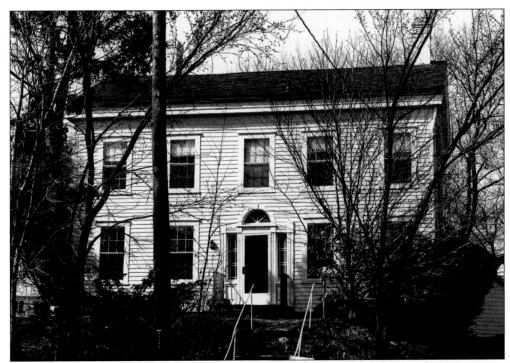

The house built by Eli Whitney II in 1845, now 1322 Whitney Avenue, was a boardinghouse for workers at Whitney's upper armory, or pistol factory, on nearby Mill River.

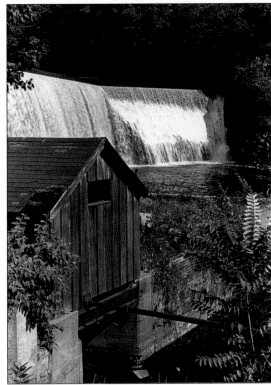

This dam was built in 1860 by Eli Whitney II above the Whitney company complex. The lake not only supplied power for the armory machinery but also served as the reservoir for the New Haven Water Company, presided over by Whitney. (Photograph by Lee Robinson.)

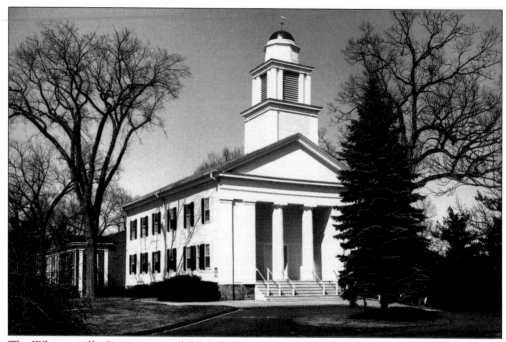

The Whitneyville Congregational Church, built in 1834, is an important historical and cultural structure in town.

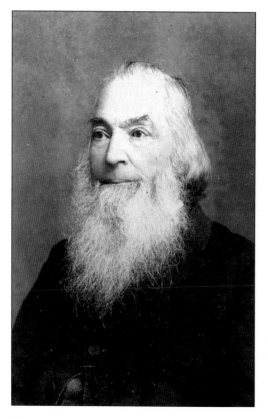

The Reverend Austin Putnam was pastor of the Whitneyville Congregational Church from 1838 to 1887. Putnam Avenue is named after him.

The Joseph Smith house once stood at the corner of Whitney Avenue and Augur Street. At one time, the structure served as the Whitneyville post office.

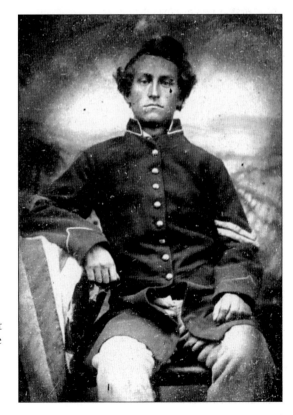

This portrait from a daguerreotype is of William F. Smith, who wears the uniform of Company F, 6th Connecticut Volunteers, c. 1861. Smith served in the Civil War from 1861 to 1864. He resided at 1140 Whitney Avenue, just north of the present site of Hamden Hall Country Day School.

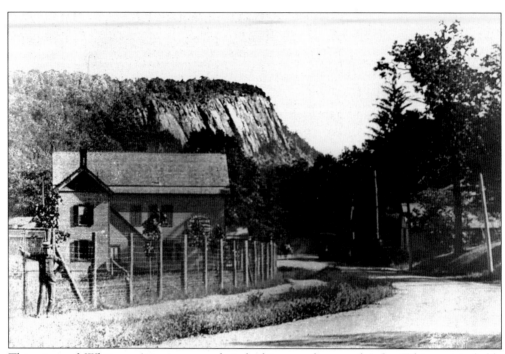

This view of Whitney Avenue was taken looking south toward Lake Whitney, probably c. 1900, with a horse-drawn trolley coming up the hill. (Photograph by H. B. Welch.)

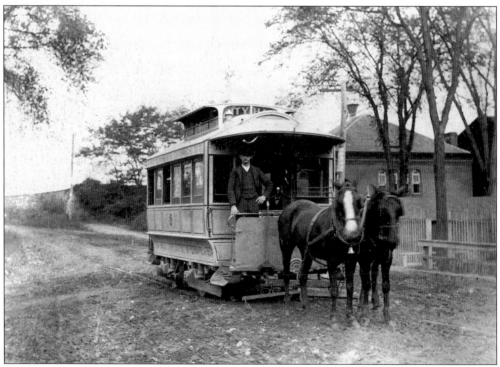

On its route up Whitney Avenue, a horsecar pauses outside of the Whitney Firearms Company c. 1880. (Courtesy the New Haven Colony Historical Society.)

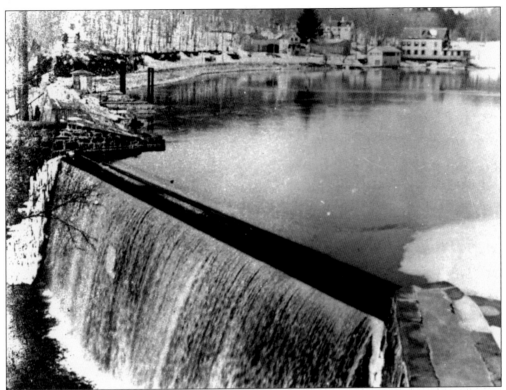

Here is a view of Lake Whitney, with the dam in the foreground and Day's store and boathouse in the background by the large evergreen tree.

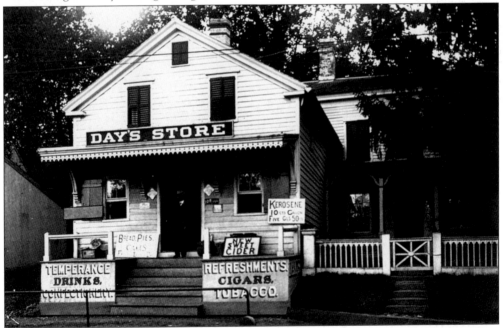

William Day's store, pictured here in the early 20th century, was located on the western shore of Lake Whitney. (Photograph by Bernard S. Budge.)

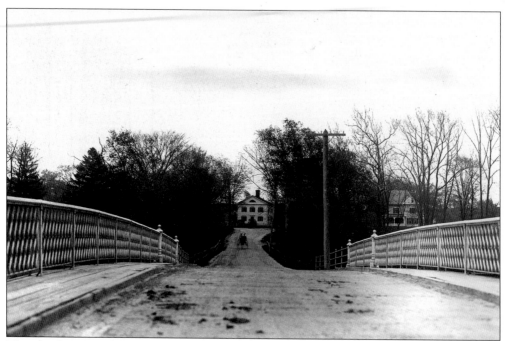

This was the view east across the Davis Street bridge over Lake Whitney *c.* 1905. (Photograph by T. S. Bronson; courtesy the New Haven Colony Historical Society.)

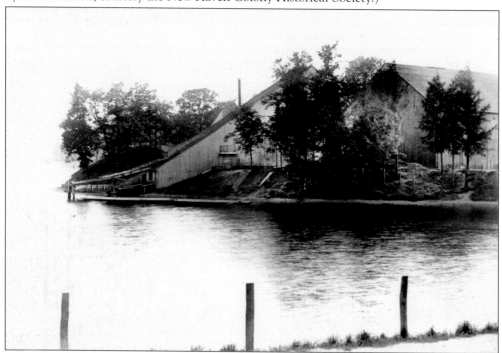

The New Haven Ice Company operates on Lake Whitney *c.* 1890. Ice was first cut on Lake Whitney in 1865. Once the water froze, teams of horses pulling ice cutters were drawn up and down the surface. The slabs of ice were then guided to the icehouse, where they were stored in sawdust. (Photograph by Myron W. Filley; courtesy the New Haven Colony Historical Society.)

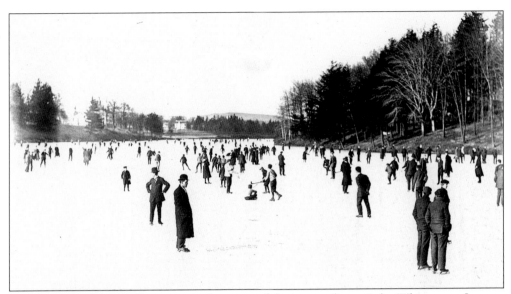

Residents of Whitneyville enjoy an afternoon of skating on frozen Lake Whitney on January 19, 1908. The lake has had a long and illustrious history. In the late 17th century, the first dam was built on Mill River to power Todd's gristmill for New Haven Colony. In 1798, Eli Whitney reconstructed the six-foot-high dam and installed waterwheels to power the Whitney armory works. The dam was further raised in 1840, when the waterwheels were replaced by hydraulic turbines, and again in 1860. Lake Whitney not only powered the Whitney armory but also served as the first reservoir for the New Haven Water Company. (Photograph by T. S. Bronson; courtesy the New Haven Colony Historical Society.)

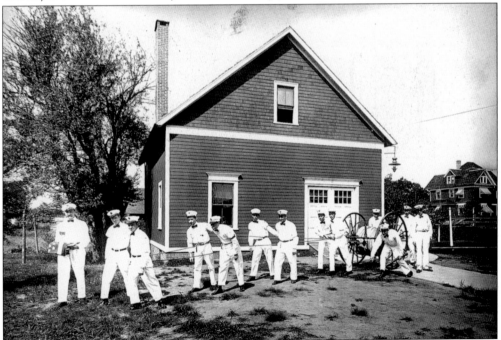

This group portrait of the Putnam Avenue Fire Company was probably taken in the late 19th century.

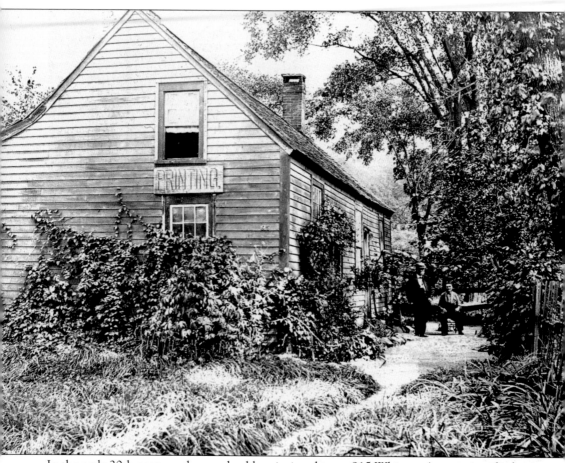

In the early 20th century, the ramshackle printing shop at 915 Whitney Avenue was the home of William Baldwin Beamish (seated). Beamish was a hermit who for 40 years was believed to be a man but, upon needing medical care, was discovered to be a woman. A Mrs. Beamish had supposedly died nearly three decades earlier, leading to the speculation that the husband lay buried in the Whitneyville Cemetery while the wife assumed his identity. Beamish only allowed men into the house; whenever a woman entered, Beamish would fly into a rage.

Evelena Bassett (1898–c. 1995) was the daughter of Louis L. and Florence Crook Bassett. The Bassett family, which at the time of this photograph had an artesian well–digging business, resided on Ralston Avenue in Whitneyville and, later, at 905 Ridge Road, which was part of the extensive holdings of the Bassett family in New Haven and Hamden for more than 200 years. Louis L. Bassett had wanted to construct a subdivision around the Ridge Road home, but the Depression put an end to his plans. Land bordered by Ridge Road and Waite Street, donated to the town by later members of the family, became Bassett Park.

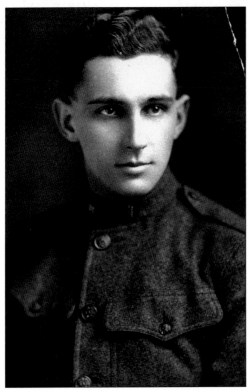

Leverett A. Bassett (1895–1958), the older brother of Evelena, poses for his portrait in his World War I uniform c. 1918.

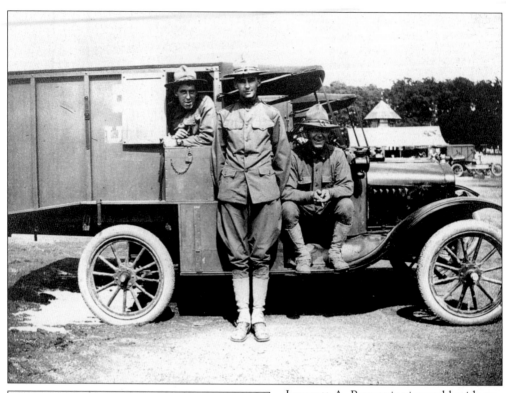

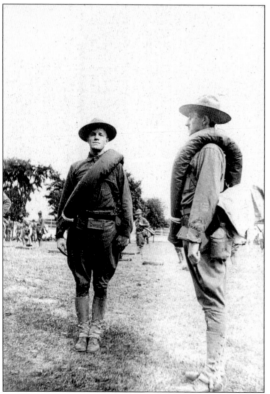

Leverett A. Bassett is pictured beside an army vehicle (above) and on the parade grounds (left) at the training camp in Allentown, Pennsylvania, *c.* 1918.

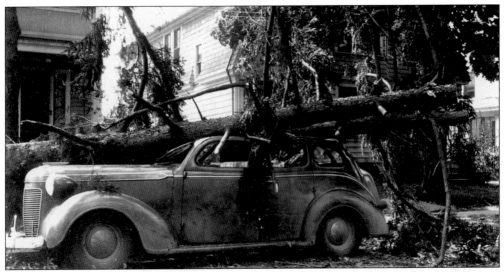

The hurricane of September 1938 was long remembered as one of the most devastating and destructive ever to hit Connecticut. The effects of the hurricane are seen on and around Putnam Avenue. (Photograph by Fred A. Tyrrell.)

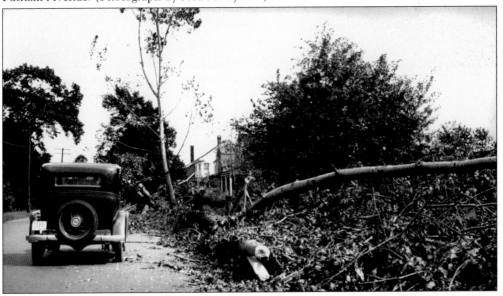

THORNTON WILDER

APRIL 17, 1997 HAMDEN, CONNECTICUT
FIRST DAY OF ISSUE STAMP CEREMONY

Pulitzer-winning playwright and novelist Thornton Wilder was Whitneyville's most famous 20th-century resident. He lived in Hamden from 1929 until his death in 1975. Wilder authored such classics as *The Bridge of San Luis Rey* (1927), *Our Town* (1938), and *The Skin of Our Teeth* (1943). Wilder is buried in Mount Carmel Cemetery.

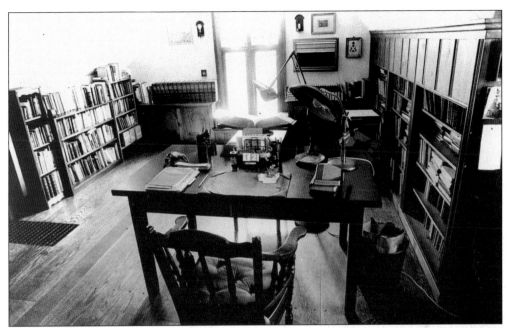

Shown is Thornton Wilder's study in his Deepwood Drive home. The room reflects his Spartan, nonmaterialistic lifestyle. Today, the study is preserved in Hamden's Miller Library.

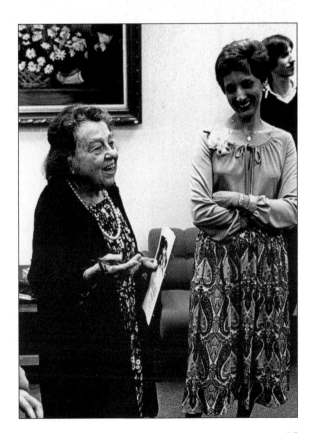

Isabel Wilder (left), Thornton's sister, was a widely known novelist who, after her brother's death, lived in his house on Deepwood Drive. (Photograph by Lee Robinson.)

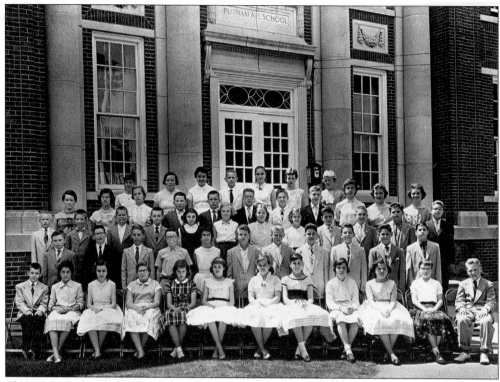

The sixth grade of the Putnam Avenue School is pictured in June 1957. (Photograph by Jay Storm.)

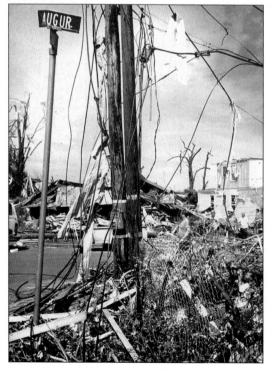

On July 10, 1989, a tornado hit Hamden and surrounding areas, leaving a path of destruction in its wake. The upper Whitneyville area was especially hard hit, with 250 residents homeless, 500 structures damaged, and 7,000 dwellings without power. This series of photographs by Colleen Yacono begins with a representation of some of the damage at the corner of Augur and Newhall Streets.

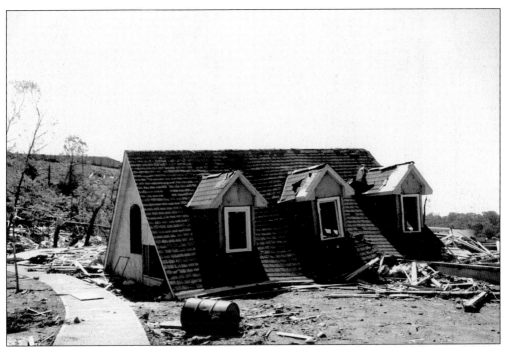

The 1989 tornado decapitated a house on Blake Road (above) and turned the Hamden Industrial Park, off Dixwell Avenue, into a pile a twisted metal (below).

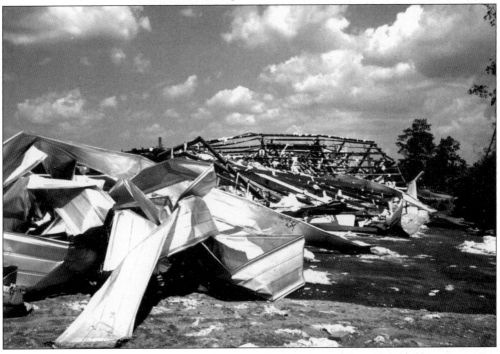

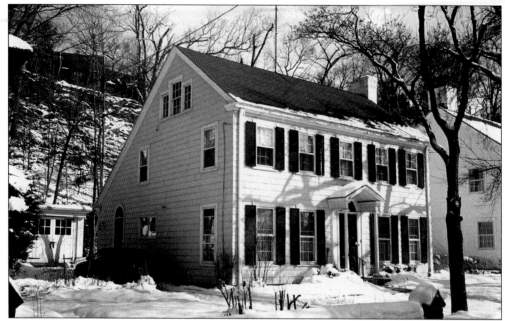

Hamden contains a number of homes designed by noted builder Alice Washburn, whose style was distinctively Colonial Revival. Pictured on Mill Rock Road is one of the Washburn houses, which are recognized for their craftsmanship and architectural detail.

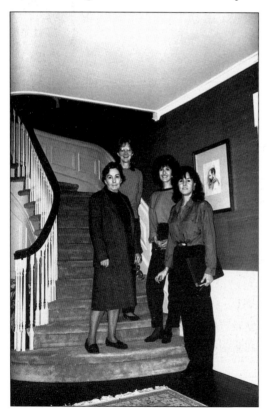

In 1990, the Hamden Arts Commission sponsored an Alice Washburn Celebration. Standing in the front hall of a Washburn home, from left to right, are Hamden town historian Martha Becker, Washburn scholar Martha Yellig, Maria Poirier, and Hamden Arts Commission coordinator Mimsie Coleman.

Two
PINE ROCK, HAMDEN
PLAINS, AND HIGHWOOD

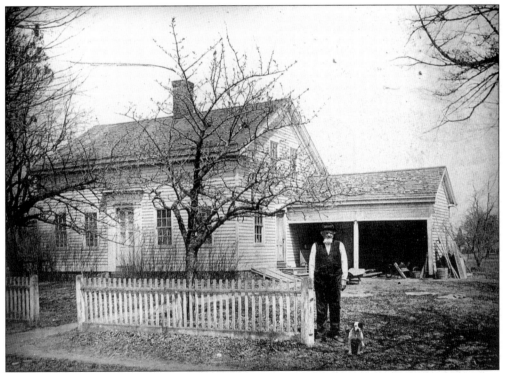

William Henry Woodin (1832–1905) stands in front of his house, now 445 Woodin Street, built *c.* 1840 by his father, Charles. The Woodins were one of the earliest families in the Hamden Plains area, settling here in the middle of the 17th century.

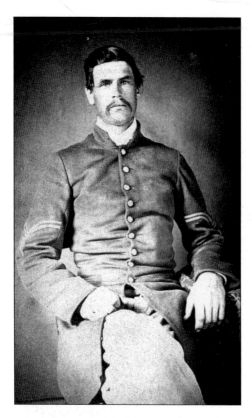

Benjamin Woodin was the son of William Henry Woodin. Born in 1828, he worked at the Candee Factory, which made rubber shoes, and at Churchill's augur shop. He is pictured in a daguerreotype image accoutered in his Civil War uniform of I Company, 24th Regiment (left) and later, when despite the loss of an arm in the war, he became a successful fruit grower, served as Hamden's assessor, and represented the town in the state legislature from 1887 to 1895.

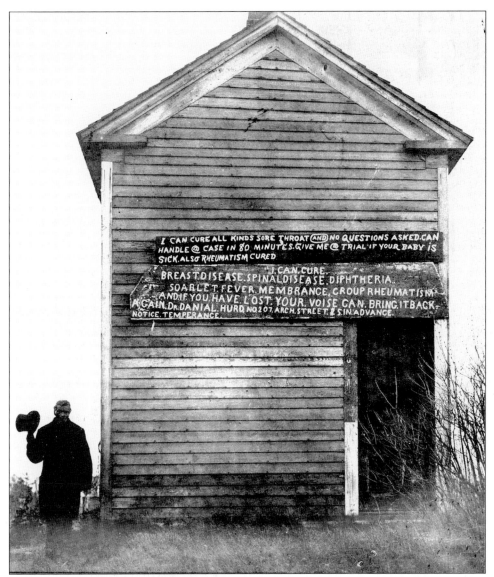

Dr. Danial Hurd, a black healer, poses outside his Highwood home and office in the 1870s. A former slave from Virginia, Hurd made his rounds in a silk hat, Prince Albert coat, and dark striped trousers. The signs above his door read: "I can cure all kinds sore throat and no questions asked. Can handle @ case in 80 minutes. Give me @ trial if your baby is sick. Also rheumatism cured. . . . I can cure breast disease, spinal disease, diphtheria, soarlet [sic] fever, membrance, croup, rheumatism and if you have lost your voise [sic] can bring it back again. Dr. Danial Hurd. No. 207 Arch Street. $5 in advance. Notice: Temperance." In a period when temperance was a popular reform measure, the notice was probably meant to assure patients that Hurd did not use alcohol in his treatments.

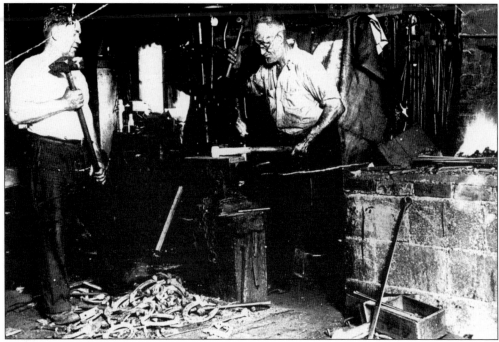

George O'Connell (left) works in his blacksmith shop, at the corner of Dixwell Avenue and Morse Street, with William Boyle, probably in the late 19th century.

From 1874, this Morse Street building was home to a number of organizations including the Lebanon Mission, the Highwood Volunteer Fire Association, St. Anthony's Church, St. Ann's Church, the Henry Hall Organ Company, and High Precision Inc. In 1974, it was torn down to make way for a larger building for High Precision.

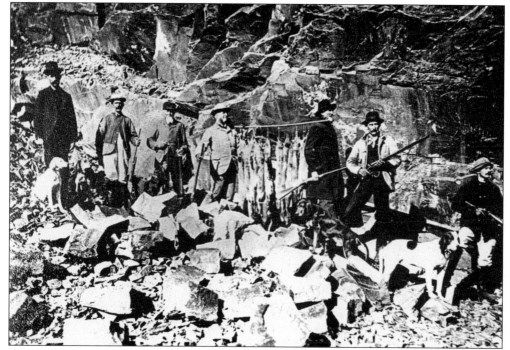

Pictured in this *c.* 1886 portrait of fox hunting at Pine Rock Indian Cave, from left to right, are William S. Thomas Jr., Gus Potter, John Keep, E. K. Sperry, William A. Thomas Sr. (who owned the quarry on the site), Frank Thomas, and Henry Mix.

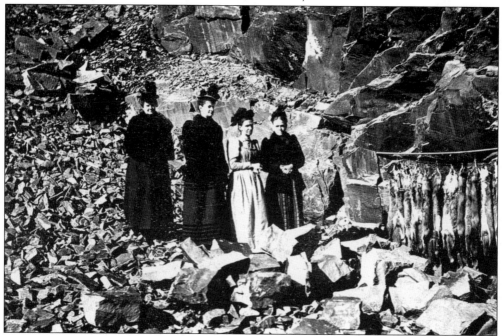

Shown is the female half of the *c.* 1886 fox-hunting party at Pine Rock Indian Cave. From left to right are Mrs. E. K. Sperry, Edith Sperry, Mrs. William A. Thomas Jr., and Mrs. William A. Thomas Sr.

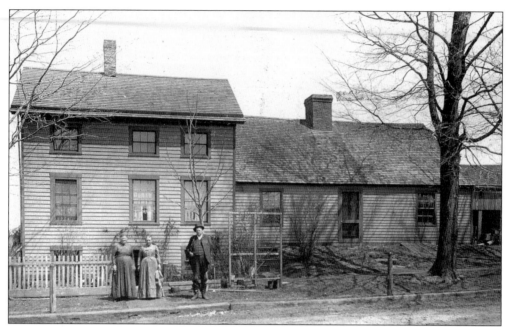

Benjamin C. Woodin pauses in front of his house, at 475 Woodin Street, with his wife and sister in 1904.

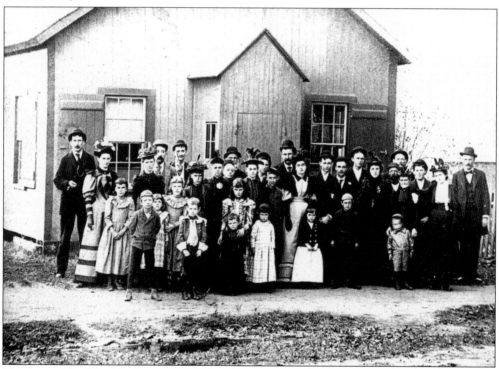

Members of St. John the Baptist Catholic Church gather in front of their first meetinghouse, on or near Alstrum Street in Highwood, c. the 1890s. The structure was originally a bicycle clubhouse before it was purchased by William Benham and given to the parish. The congregation's present church, on Dixwell Avenue in New Haven, was built in 1919.

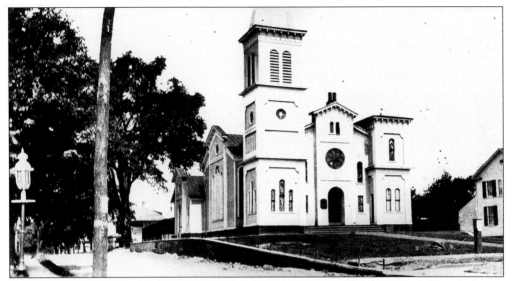

Built in 1813, the Hamden Plains Methodist Church, at Dixwell Avenue and Church Street, burned to the ground in 1918.

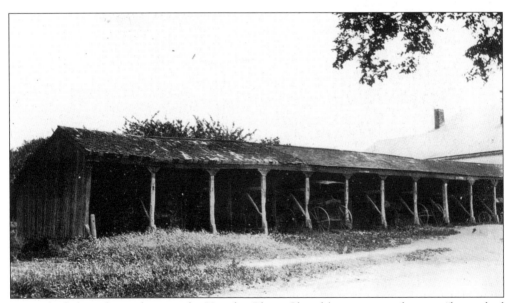

Horse sheds (seen here adjoining the Hamden Plains Church) gave rise to the term "horse shed Christians," used to describe those who lingered outside during the service.

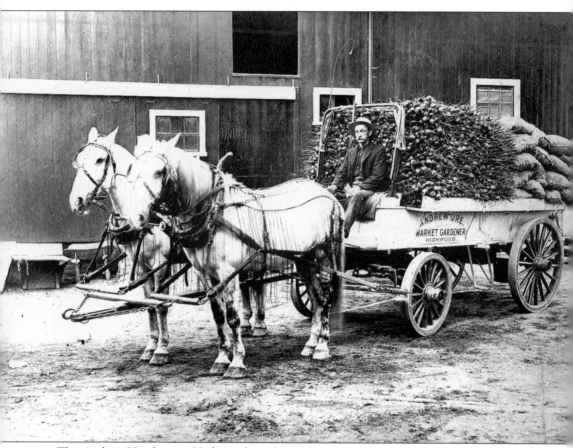

The Andrew Ure farm in Highwood was located at the present site of Oberlin Road and Pine Rock Avenue. This *c.* 1888 image shows driver John Hyland, whose house on Circular Avenue opposite Lexington Street still exists.

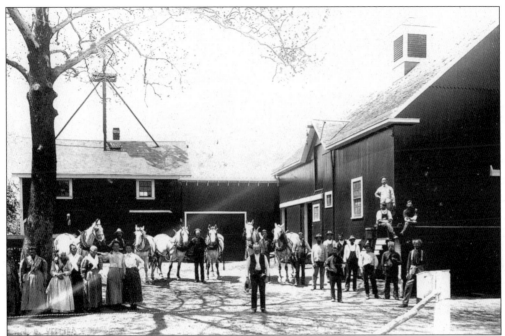

The workers at the Ure farm on Pine Rock Avenue, seen here c. 1888, reflected the rising number of Italian-American immigrants in Hamden at the time. By 1917, Italians constituted nearly one third of Hamden's population, making them the second-largest (after the Irish) single immigrant group in town. These "Paesans," part of a tide of late-19th-century immigration that swelled Connecticut cities and provided cheap labor, worked in the fields from sunup to sundown for $1 a day. Born in 1854, John Della Vecchia Sr. (below, back row left) went on to own a general store on St. Mary's Street, where he and his wife raised 10 children. (Below, John Della Vecchia collection.)

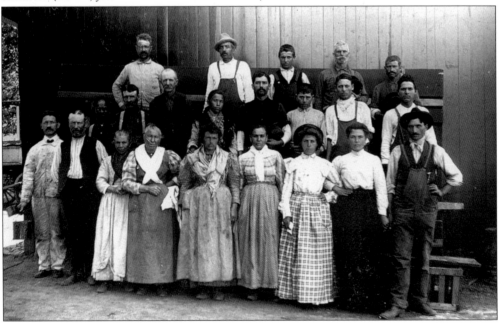

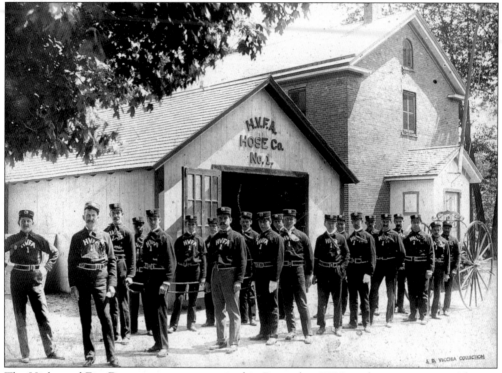

The Highwood Fire Department was organized in December 1896, with its quarters on Alstrum Street beside the Highwood School.

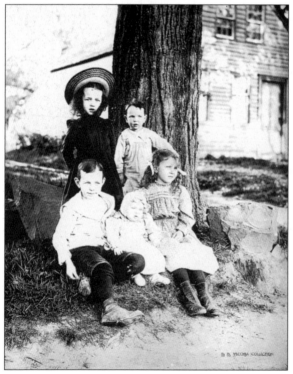

The Tyrrell children are pictured *c.* 1900 in front of the family farmhouse, located on Dixwell Avenue opposite Woodin Street. They are, from left to right, as follows: (front row) Fred A. Tyrrell, Edith Adelle Tyrrell, and Myrtle Tyrrell; (back row) Grace May Tyrrell and Gordon Eugene Tyrrell. (John Della Vecchia collection.)

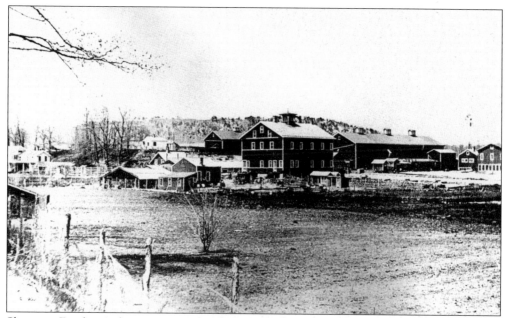

Shown is Farnham's farm *c.* 1915. The photograph was taken on Crescent Street near Rogers Drive, with Pine Rock in the distance. After World War II, the area became a commercial and retail district featuring strip malls and shopping plazas, somewhat dubiously known as the Magic Mile. Nonetheless, some family farms, such as that of the Hindingers, still carry on a century-old tradition in the western hills.

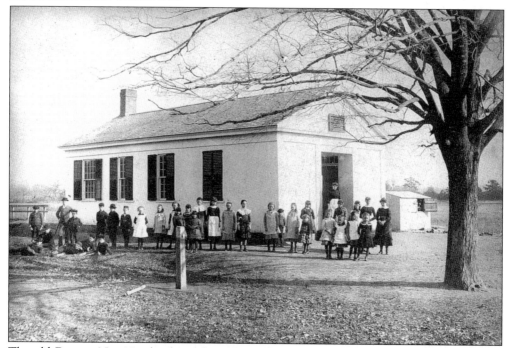

The old District No. 11 school stands on Dixwell Avenue at Haig Street in Hamden Plains. The teacher in the doorway is Hattie Warner Broadbent, then around 18 years old. In 1902, a new building was erected.

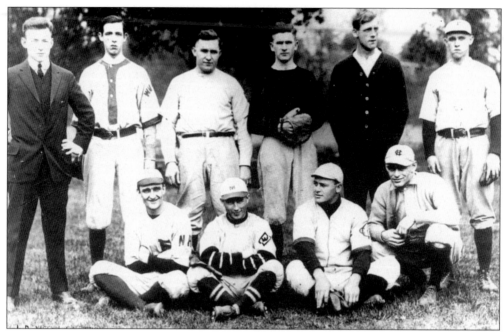

The Hamden all-star baseball team played at Weiss Field on Woodin Street. The players are pictured *c.* 1910 with coach Michael J. Whalen (left), for whom the Hamden middle school was later named. Three players are identified: (front row) Hugh Foster, second from the left, and Bill O'Connell, far right; (back row) George C. Rogers, third from the left. Foster also played for the professional New Haven Connecticut League team in 1910. Other local players included Chief Meyers (1919), Chief Bender (1920–1921), William "Wild Bill" Donovan (1922–1923), Clyde Milan (1924), Neal Ball (1925, 1927), and Jack Flynn (1926).

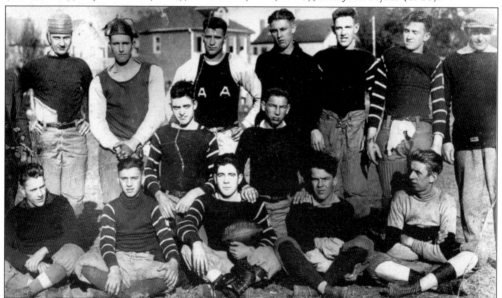

Shown is the Montrose football team of 1915. Standing in the back row, from left to right, are George C. Rogers, Frank Connell, Johnny Pedelley, Bill Chapproth, Bill Halpren, Young Myers, and Joe Cosenza. The remaining players are not identified.

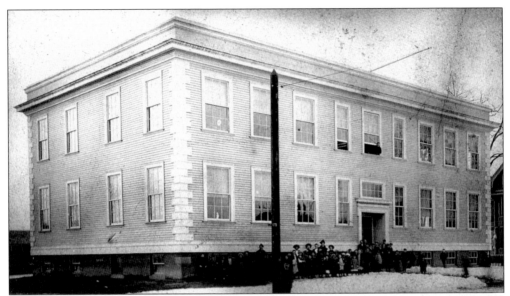

The Pine Street School, pictured *c.* 1910, was later named the Margaret L. Keefe School. (Gift of Jeanette Sturtze Miller.)

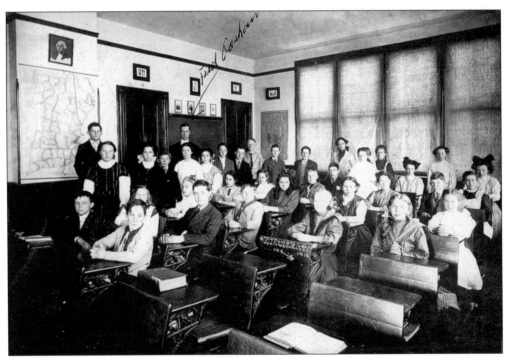

When this picture of the interior of the Pine Street School was taken *c.* 1910, the schoolmaster was Fred Gorham (standing between the doors).

41

The Church Street School, built in 1913, was designed by C. Frederick Townsend.

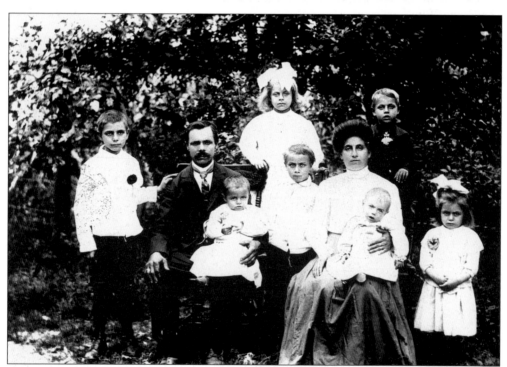

Philip Palmieri, pictured with his family on Warner Street c. 1910, was a member of the committee that founded St. Ann's Roman Catholic Church, at the corner of Arch Street and Dixwell Avenue.

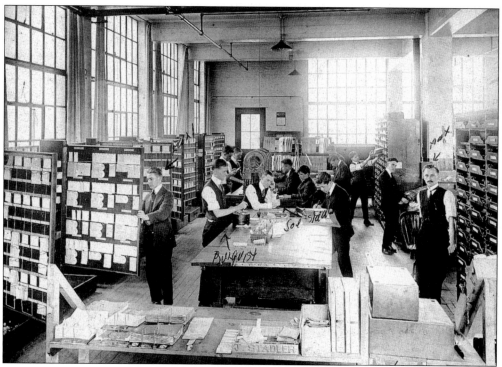

The Acme Wire Company was located on Dixwell Avenue opposite Scott Street. These photographs date from 1916 and 1917.

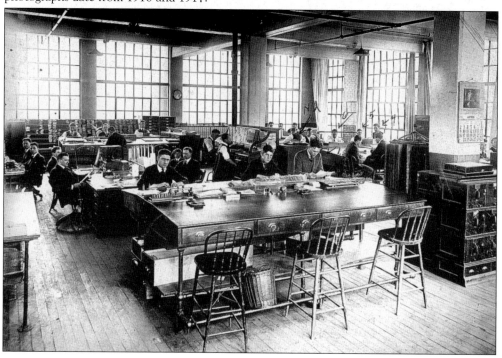

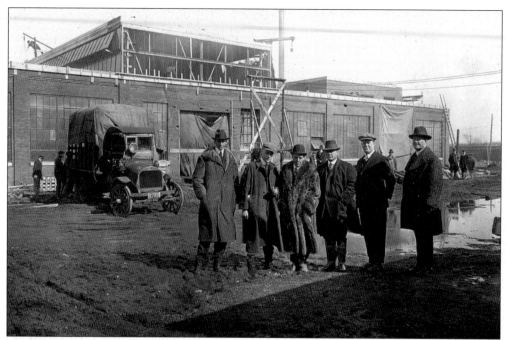

The Safety Car Company stood on the southeast corner of Dixwell and Putnam Avenues. Among the men pictured outside in 1918 is plant engineer Claude C. Sibley (second from the left). (Gift of Jane Sibley.)

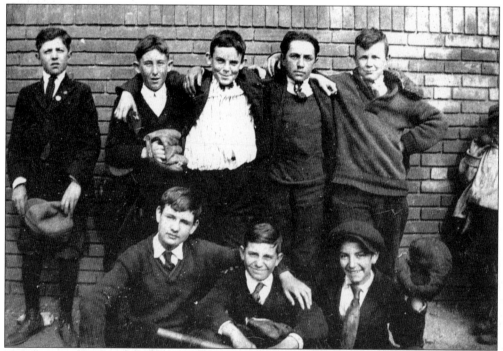

This is a portrait of the Newhall School baseball team in 1920. From left to right are the following: (front row) Fred Johnson, Tony Festa, and Pat Melillo; (back row) James Grillo (manager), George Rogers, George Keenan, January Maggi, and Happy Shea.

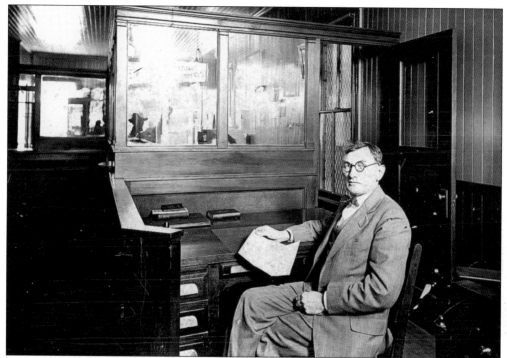

Walter T. Kenyon was the first president of the Hamden Bank and Trust Company, founded in 1924. Kenyon served as the Hamden tax collector for 26 years. This photograph was taken in the bank's old location, at 862 Dixwell Avenue, before the completion of the new bank, at the corner of Circular and Dixwell Avenues.

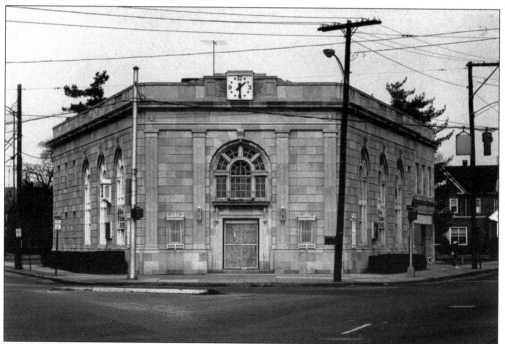

Pictured is the Hamden Bank and Trust Company, at 1120 Dixwell Avenue, in 1926.

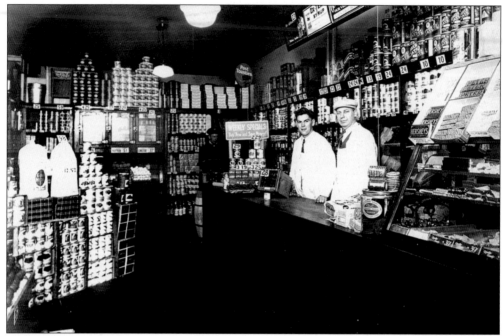

The old Economy store, on Dixwell Avenue, later became the First National Bank. This 1927 photograph shows manager Charles Miller (right) and clerk Lewis B. Bischoff, age 16. (Gift of Lillian Bischoff.)

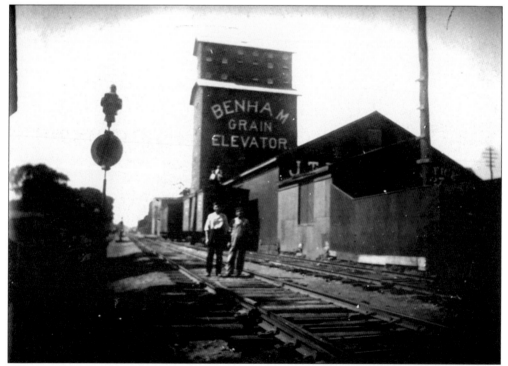

This postcard, possibly dating from the 1930s, shows the old circus grounds and Benham Grain Elevator in Highwood.

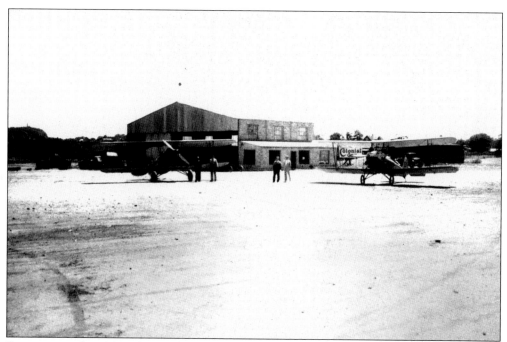

Beginning in the 1930s, the Hamden Airport was located north of Morse Street and east of the railroad tracks in Highwood. For a number of summers prior to 1947, the Ringling Brothers and Barnum and Bailey Circus performed here annually.

Rochford Field, pictured in 1946, was named for F. Raymond Rochford, who served as Hamden's first selectman during the 1930s.

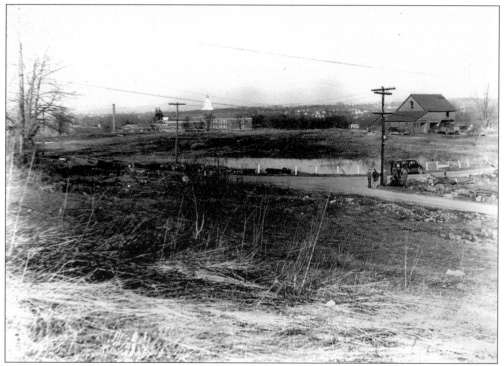

The newly built Hamden High School is shown in this c. 1935 view, taken from the southwest.

The Pine Rock Quarry operated into the 1930s. (John Della Vecchia Collection.)

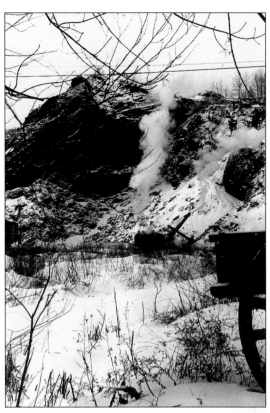

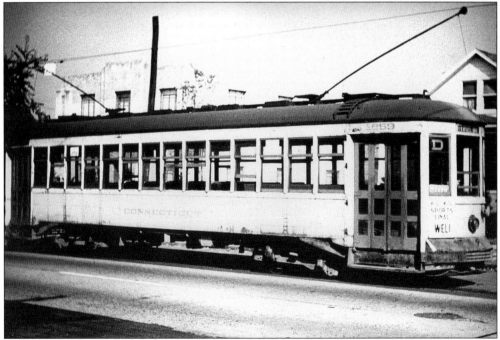

This view, titled "End of the Line," shows the trolley car on Dixwell Avenue in 1948 on the last day it ran in Hamden. (Photograph by Leonora Larson.)

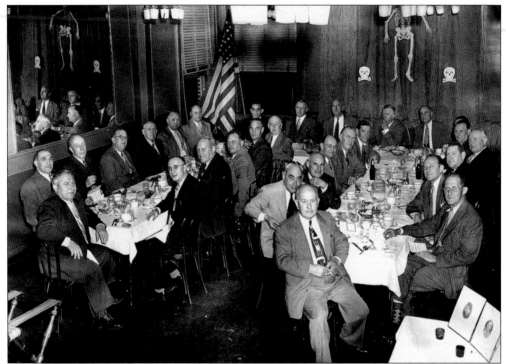

The members of the Last Man's Club pause for a group photograph during the club's meeting on May 3, 1941, at the Café Mellone in New Haven. The Last Man's Club, founded in 1936, had as its members veterans, including a number from Hamden, who met once a year. Their fellowship was based on a pledge, with "no point or purpose other than that each member would try to outlive the other in order to win the bottle of wine to be quaffed by the last survivor." Note the makeshift shrine (lower right) to members who had died during the preceding year.

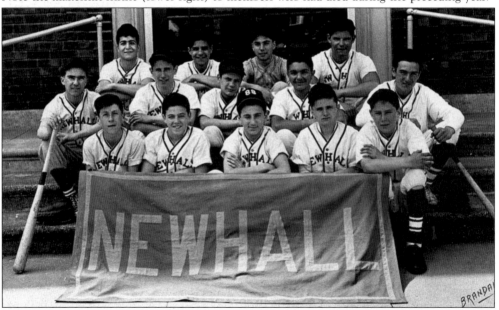

Pictured are the members of the Newhall School baseball team of 1954.

Three
SPRING GLEN

During the late 19th century, the area that is today bounded roughly by Waite Street on the south and Skiff Street on the north was given the name Spring Glen by James J. Webb, a former Santa Fe trader who purchased land in 1858 and developed it into a fine dairy farm. In the 1920s, the Webb farm and most of the neighboring farmland were sold to developers and divided into building lots. This view looks north along Whitney Avenue, probably in the early 20th century.

Whitney Avenue in Spring Glen was paved for the first time in the 1930s.

Spring Glen features a concentration of places of worship exemplifying the broad range of religious traditions in modern-day Hamden. Shown is Spring Glen Congregational Church, on Whitney Avenue.

St. Rita's Roman Catholic Church, built in 1964, is pictured in September 2000.

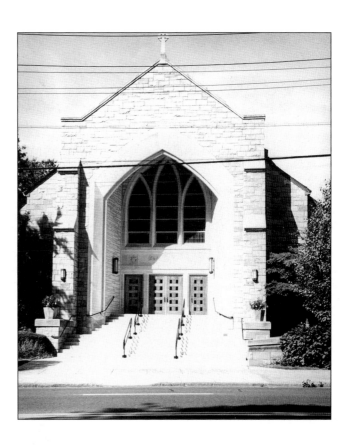

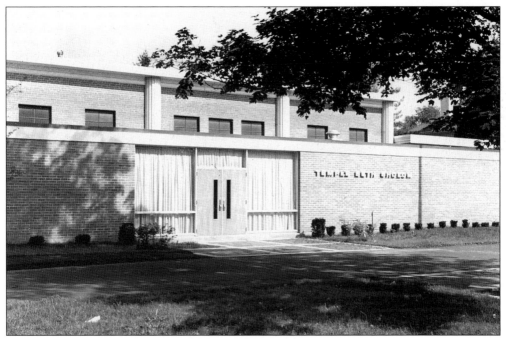

Only a short distance up Whitney Avenue is Temple Beth Shalom.

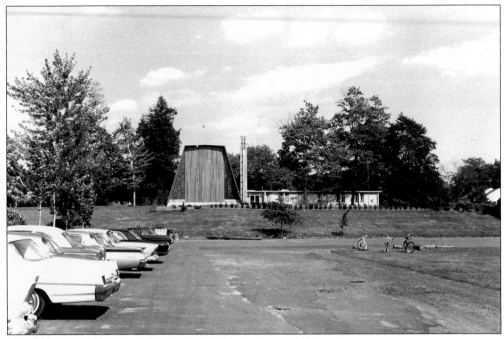

The Korean Presbyterian Church is on Glen Parkway.

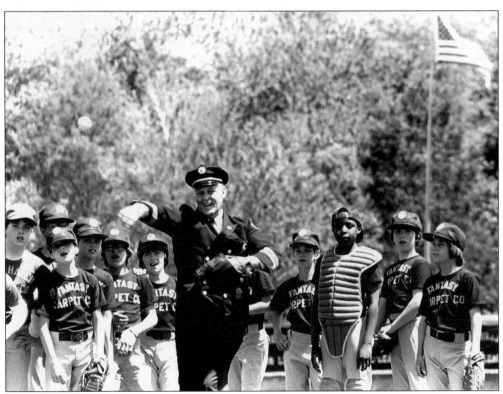

On opening day in 1977, Fire Chief Paul Leddy throws out the first ball at Bassett Park for the Hamden Fathers' Baseball Association. (Photograph by Lee Robinson.)

Four
STATE STREET

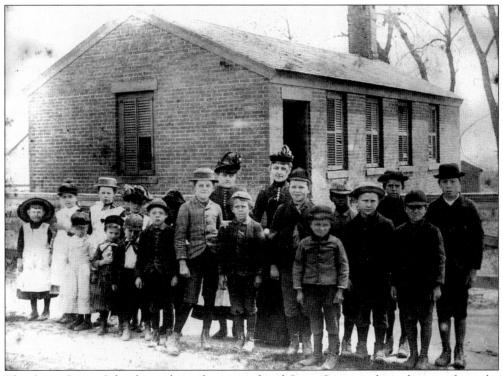

The State Street School stood on the east side of State Street a short distance from the cemetery. Built c. 1830, it remained in use until 1916. Alice G. Dickerman (center) was the only teacher of record for all grades in the school in the 1880s, when this photograph was taken. To accommodate the growing numbers of children, the town built a separate annex in the late 19th century, a one-room wooden schoolhouse at the south of the cemetery. Having proved to be incapable of handling 20th-century needs, most one-room structures were replaced during the period after 1912. (Photograph by Bernard S. Budge.)

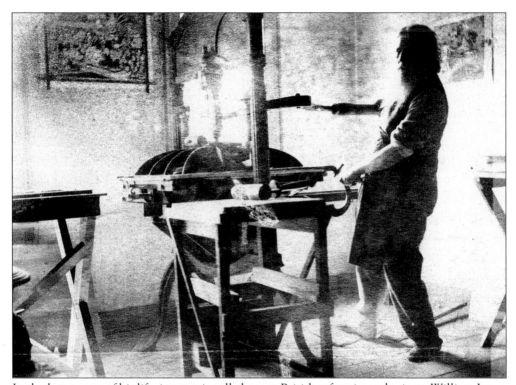

In the latter years of his life, internationally known British reformist and printer William James Linton resided in Hamden on State Street in the house he called Appledore. He is shown here at his Appledore press. Linton came to America in the 1860s and eventually settled in Hamden in 1870, where he wrote, engraved, and published his masterpiece, *The Masters of Wood Engraving*, in 1889. Friend and intimate of many of the great writers of the 19th century in America and England, Linton died in 1897 and lies buried in the little cemetery on State Street. The Hamden Historical Society owns the Appledore press and a signed copy of *Ultima Verba*, Linton's last work.

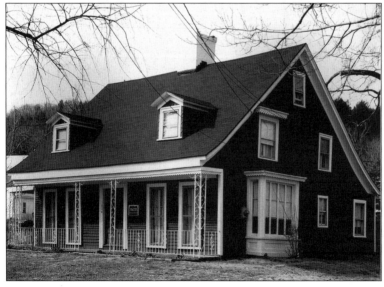

This is Appledore, Linton's home in Hamden. Built by Jared Atwater in 1785, it stood at 1804 State Street.

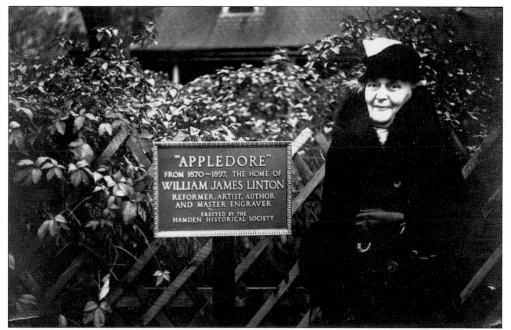

Margaret Linton Mather, age 85, stands beside the bronze plaque in front of Appledore that commemorates her father. This photograph was taken in October 1936.

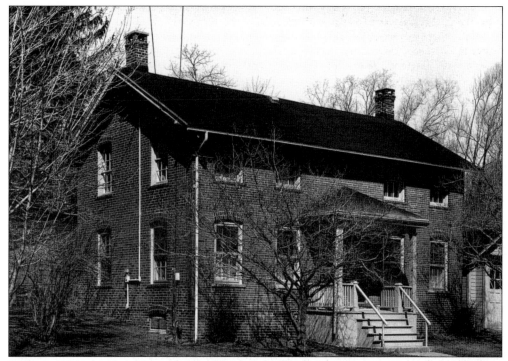

Built *c.* 1876, the Quinnipiac Brick Company building is now a private residence, at 2880 State Street.

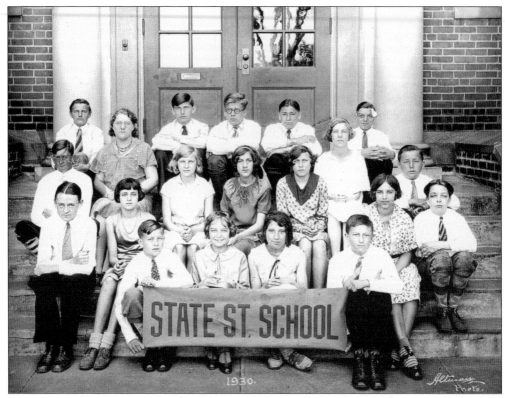

The students of the State Street School are shown in 1930. (Gift of Sandra Piontek.)

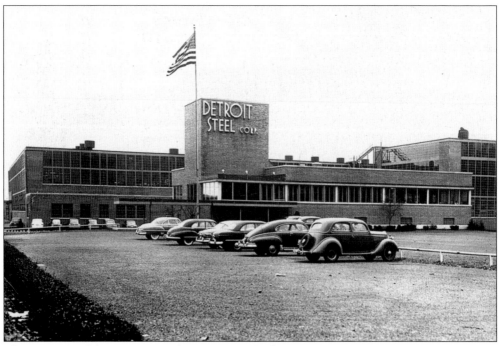

This is a view of the Detroit Steel Corporation facility, on State Street, on May 15, 1949.

Five

DUNBAR HILLS AND UPPER DIXWELL AVENUE

The Dunbar Hills District No. 10 school was a one-room structure that stood on Brook Street north of Wintergreen Avenue. Built in 1837, it was used as a school until the time of World War I, was then converted into a private dwelling, and was demolished in 1930. Dunbar Hills was named for Giles Dunbar, who, in the early 19th century, was a hayward, or constable, in the area.

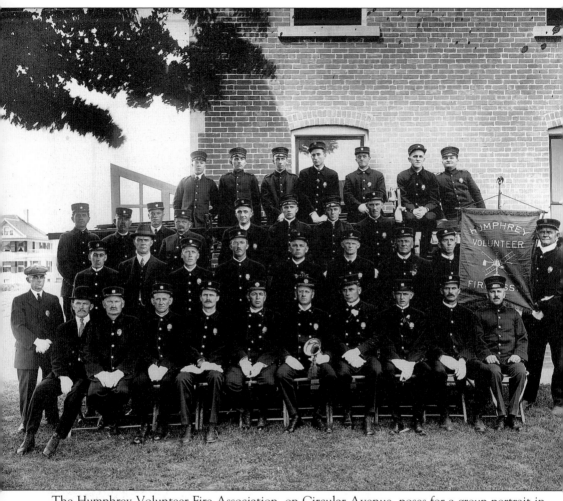

The Humphrey Volunteer Fire Association, on Circular Avenue, poses for a group portrait in 1926. Identified are the following: (first row) Everett Warner, fourth from the left; (second row) Harold Munson Lewis, third from the left, and Nelson Warner, fourth from the left.

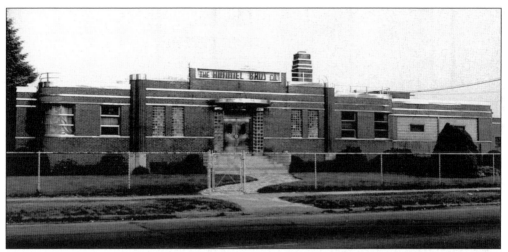

Himmel Brothers, at 1409–1415 Dixwell Avenue, made metal storefronts and other metal products. Pictured in 1937, the building shows an Art Deco influence.

The High Standard plant on Dixwell Avenue made gun parts.

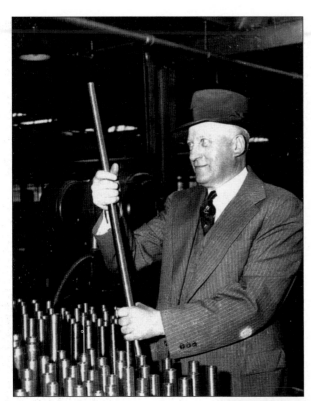

Gus Swebilius was the founder of High Standard.

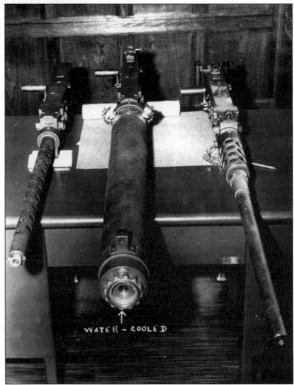

WATER – COOLED

Among its productions, High Standard made .50-caliber guns. The weapon in the middle is water-cooled, as noted.

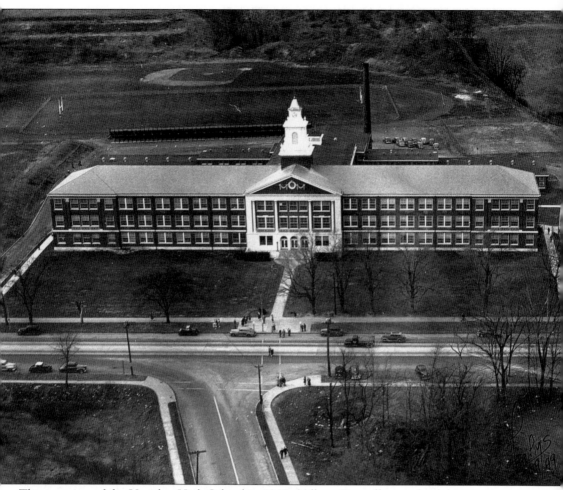
This is a view of the Hamden High School in 1949. (Albert Connally scrapbook.)

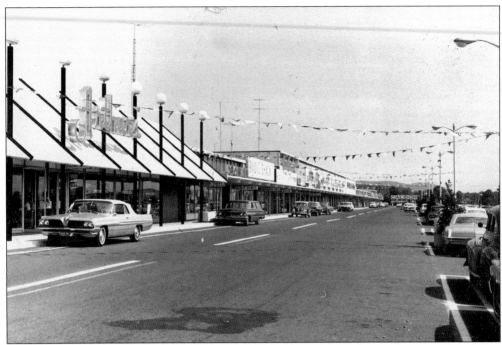

This photograph records the beginning and development of the Magic Mile. Seen are the Hamden Mart, the Cinemart Theatre, Hamden Mart Lanes, and the Ambassador Lounge and Restaurant. This stretch of Dixwell Avenue was once dominated by apple orchards.

Hamden Plaza was one of the first modern shopping malls developed in the post–World War II boom, epitomizing suburban commercial culture for the next half-century.

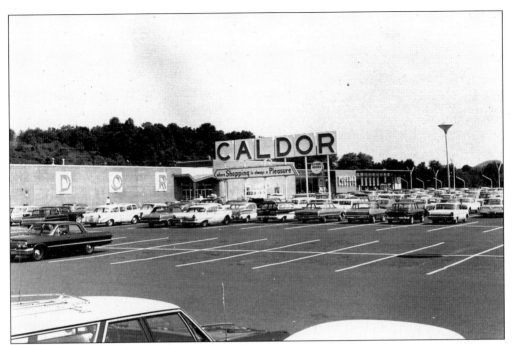

Caldor Plaza originally stood north of Hamden Plaza.

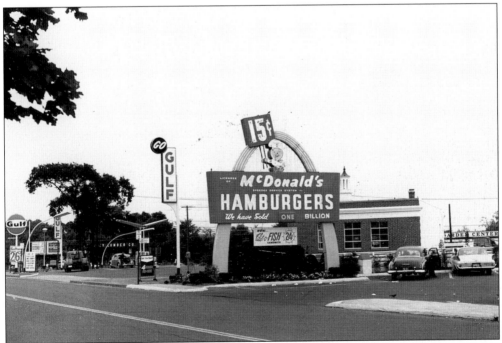

Fast-food restaurants, epitomized by McDonald's, evolved side-by-side with shopping malls. At the time of this photograph, McDonald's was selling hamburgers for 15¢. This particular franchise on Dixwell Avenue was the first in Connecticut.

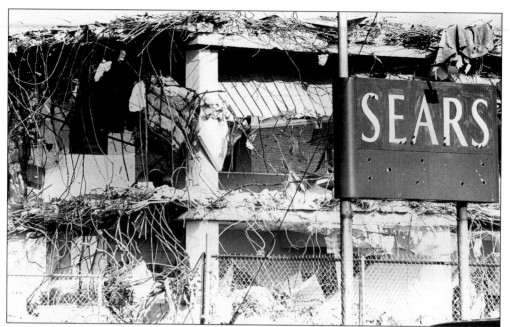

In preparation for the 21st century, the Sears building was leveled to make way for a new shopping plaza.

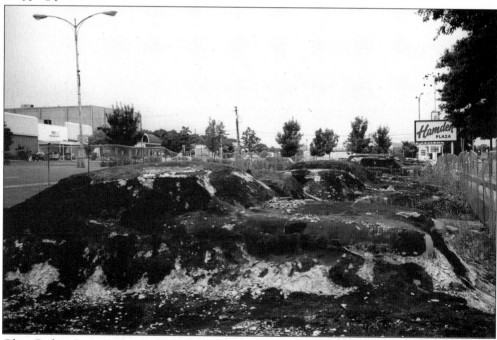

Ghost Parking Lot was created by sculptor James Wines in 1978 along Dixwell Avenue in front of the Hamden Plaza, whose owner added public art to the first shopping center in an early suburban setting. The original cars, covered in asphalt, became a renowned example of site-specific outdoor sculpture that made a statement concerning American culture and its relationship to the automobile. After falling into neglect, the sculpture was removed in the summer of 2003.

Six

WEST WOODS

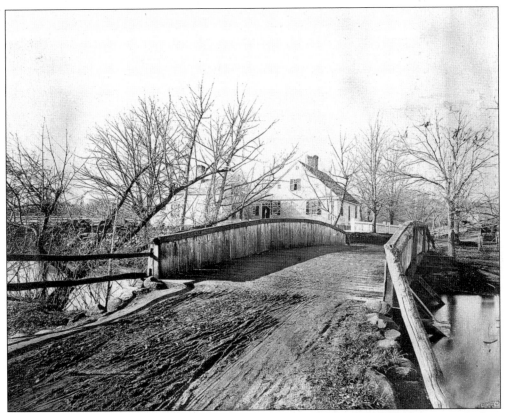

This house was built *c.* 1795 on what is now Todd Street by Dimon Roberts, a cooper. It is pictured in the 19th century, with the Farmington Canal running through the front yard. Later purchased by the Peck family, the house became known as "the old Peck place."

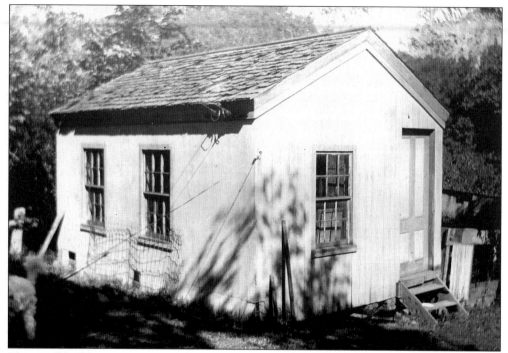

This small building was used by Alfred Hitchcock as a cobbler's shop in the early 19th century. Reputedly, Hitchcock made as many as 700 pairs of shoes here annually. In 1937, the structure was adjoined to the old Peck place.

To compute transit rates on turnpike and stagecoach routes more accurately, stone markers were placed along major roads per order of the 1767 Connecticut General Assembly. Starting at city hall in New Haven, markers were placed at one-mile intervals along Whitney Avenue to Cheshire. There were eight markers in Hamden. Shown is the ninth milestone, in front of Mount Carmel Cemetery, installed c. 1800. To avoid paying the turnpike tolls, local residents used another road through the hills west of Whitney Avenue called the shunpike. Nowadays, the road is known as Shepard Avenue.

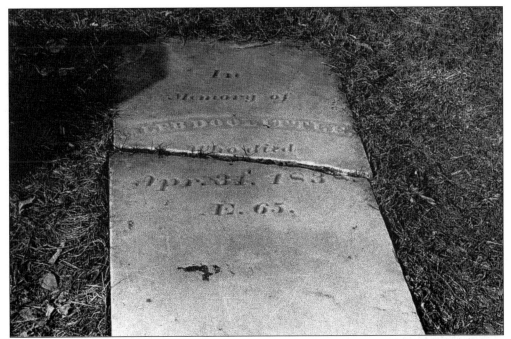

In West Woods Cemetery lies the toppled gravestone of Caleb Doolittle. It gives the date of Doolittle's date as April 31, 1838. Besides dying on a day in April that did not exist, Doolittle was known for other feats. He was a powerful wrestler among the wags of Dog Lane Court, a group of young men who met on Saturday nights at the home of Horace Bradley. In a test of strength, Doolittle once intimidated Yale students by lifting a full barrel of cider and drinking from the bunghole. (Gift of Ralph Santoro.)

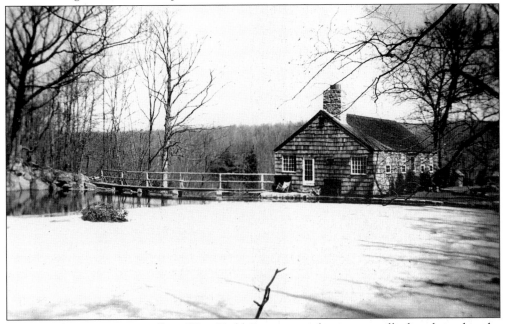

Shown is the Munson sawmill on West Todd Street, one of many sawmills that thrived in the Mount Carmel and West Woods areas in the late 18th and 19th centuries.

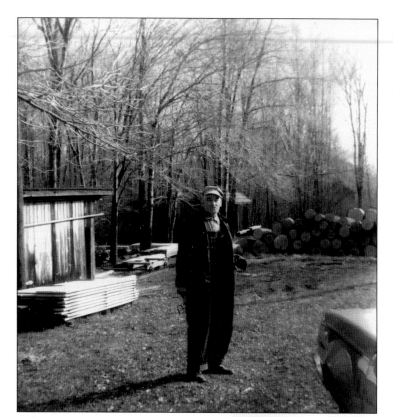

A modern-day mill hand, Arthur M. Doolittle stands at his West Todd Street sawmill.

The West Woods School, built in 1909 and closed in 1955, was the last one-room schoolhouse to be used in Hamden. After serving as the headquarters for the West Woods Volunteer Fire Company and being moved back from its original location at the corner of Still Hill and Johnson Roads, the structure became the fire company's clubhouse. The outhouse to the right was saved by Arthur Talmadge and donated to the Hamden Historical Society in 2002. It now stands behind the Jonathan Dickerman house, on Mount Carmel Avenue.

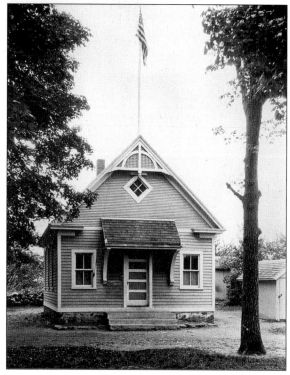

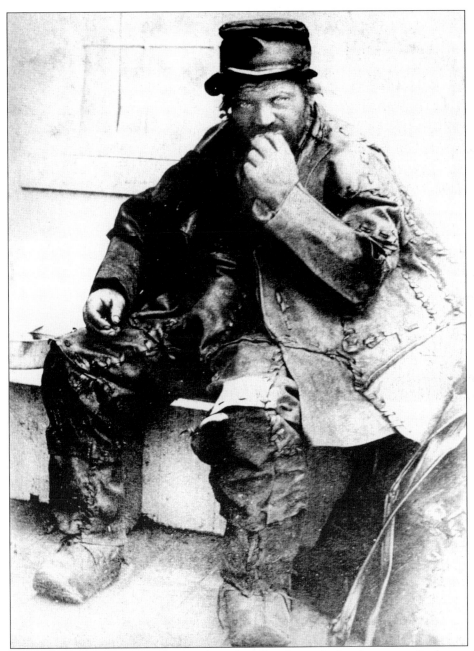

Dressed all in leather, except for the wooden soles of his shoes, the Leatherman walked a regular circuit of 366 miles several times a year from 1857 until his death in 1889. His name was Jules Bourglay, born in Lyon, France. Apparently, his marriage to the love of his life—a delicate, beautiful woman from a wealthy family—was cut short because the family's tannery business failed and their impoverishment proved too much for her to endure. His flight to America provided exactly what he sought: anonymity. Taciturn and gentle by nature, his life evoked the charity of others. Families along his circuit through Connecticut and New York fed him and watched out for him. He had caves and huts as stopping places; one such cave was deeded to the Hamden Historical Society in 1973.

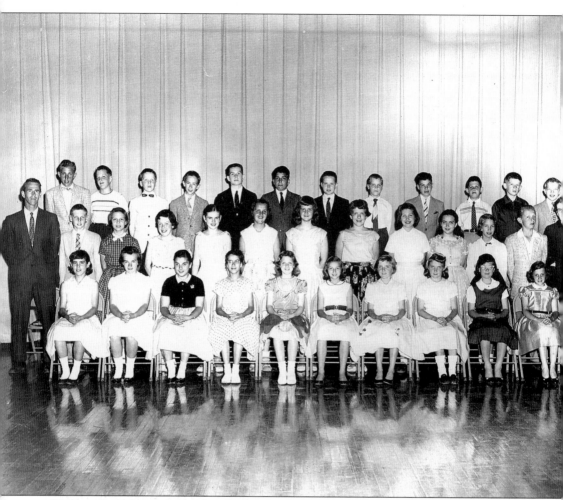

Sixth-grade students of the Alice Peck School pose with their teacher and principal for a class picture in 1957. From left to right are the following: (front row) unidentified, Joanne Pfeifer, Sandra Brancatta, Judith May, unidentified, Sharon Linke, Dorothy Decker, Pat Decker, and Jackie Harger; (middle row) teacher John W. Stevens, Richard Donath, unidentified, Heather Katley, Genie Mason, unidentified, Dorothy Finoia, Betsy Swartling, Linda Rosadini, Jean Fecci, Kathy Koch, Peter Lohr, and principal Grace Donahue; (back row) two unidentified students, David Beers, Paul Stannard, Ronald Warner, Richard DeNegris, Robert Golden, Richard Feegal, Robert Gammon, Richard Matteo, and two unidentified students. (Photograph by Lewis R. Berlepsch.)

Seven
MOUNT CARMEL

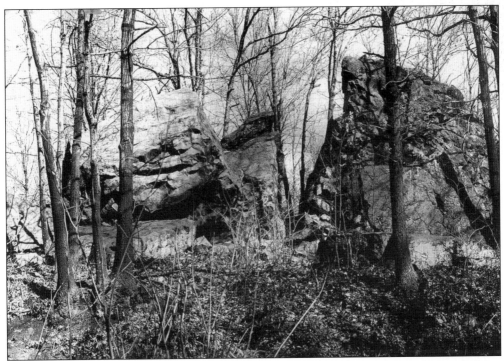

Located along Shepard Avenue, the Brethren is a series of boulders transported by prehistoric glaciers. The site is reputed to have been a gathering place for native peoples.

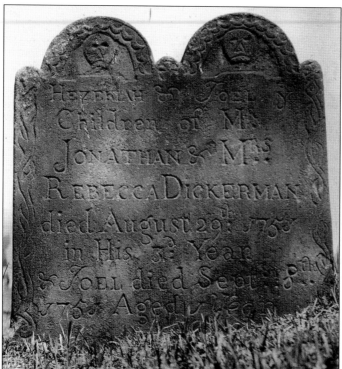

The oldest extant gravestone in Hamden is located in the Mount Carmel Cemetery. It is that of Hezekiah and Joel Dickerman. The inscription reads as follows: "Hezekiah & Joel ye Children of Mr Jonathan & Mrs Rebecca Dickerman died August 20th: 1751 in His 3d: Year & Joel died Septbr: 8th: 1751 Aged 1 Year." The Mount Carmel Ecclesiastical Society, to which the Dickermans belonged, was founded in 1757.

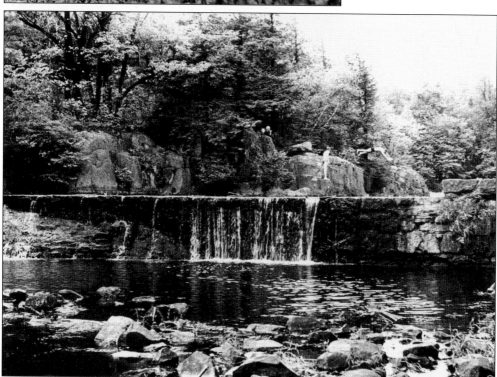

The old Munson Dam was built in 1734 by Joel Munson to operate a sawmill and gristmill on what is now called Axelrod Pond.

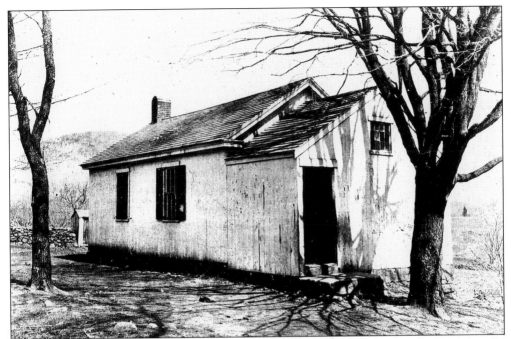

Built in 1770, the Mount Carmel School stood across from the Mount Carmel Congregational Church.

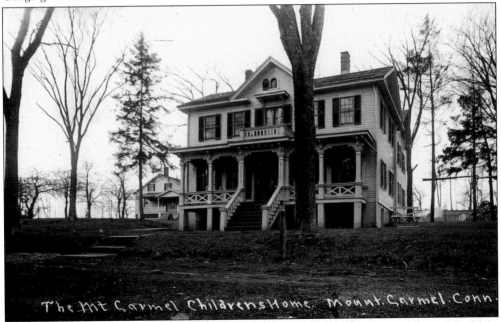

The Mt Carmel Childrens Home. Mount. Carmel. Conn.

The Young Ladies' Seminary was built *c.* 1849 and run by the Dickerman daughters, Elizabeth, Abbie, and Sarah. The school had as many as 40 to 50 students. Sadly, within 10 years, all the three Dickerman sister died, probably of consumption. Inspired by their example, the Reverend Israel Warner in 1859 wrote *The Sisters*, a book about the religious lives of the Dickermans. The building was purchased by James Ives, who lived there until his death in 1889, when it became the Mount Carmel Children's Home.

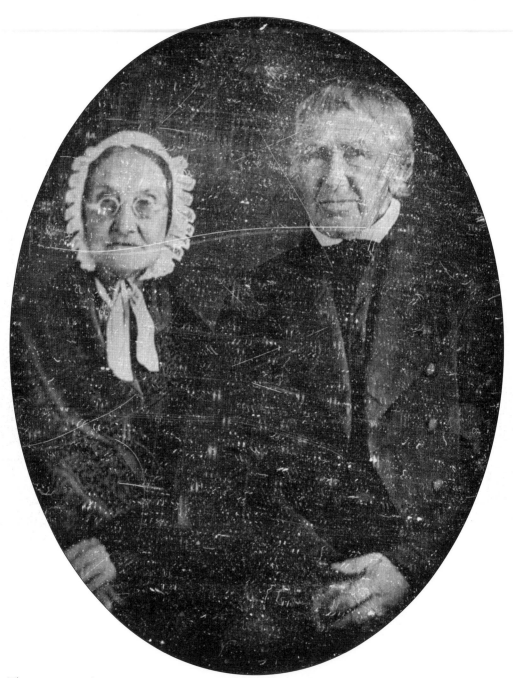

This image is a daguerreotype of Elam and Sarah Hitchcock Ives *c*. the 1840s. By the time this portrait was taken, the couple had been married nearly 50 years. Born in 1762, Elam Ives established an early industrial village centered around the fabrication of carriage parts. Ivesville is named after him, and his house still stands on Ives Street. When Long Island Sound was blockaded by the British navy during the War of 1812, Ives established an overland freight line between New York and Boston in order to keep much-needed goods flowing.

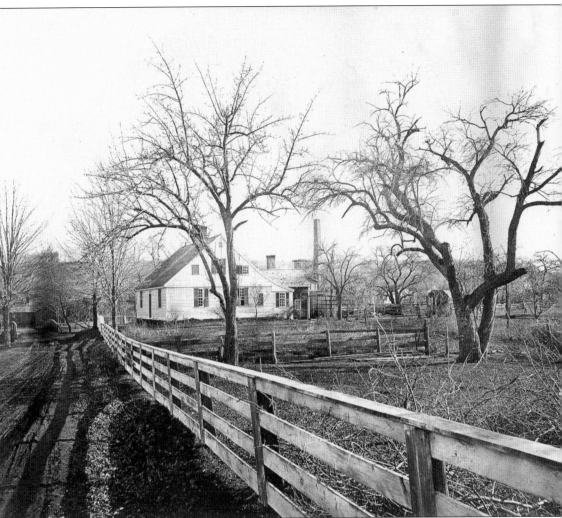

In 1790, Elam and Sarah Hitchcock Ives built their home at what is today 95 Ives Street. The chimney of the Ives factory can be seen in the background.

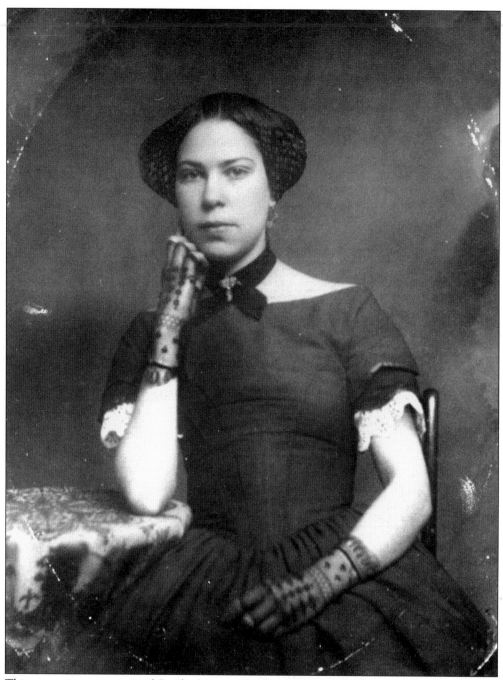

This evocative portrait is of Sarah Augusta Gorham, born in 1835 in New Haven, a lineal descendant of the Gorham and Howland settlers who came to the New World on the *Mayflower*. She taught in Hanover, Pennsylvania, and Montgomery, Alabama, before returning home due to the onset of the Civil War. On New Year's Eve 1863, she married John H. Dickerman in a double-ring ceremony that included Dickerman's sister Mary and Charles Parker. The Dickermans lived on Whitney Avenue in Mount Carmel, where Sarah died in 1903.

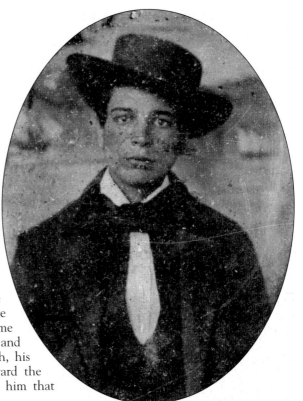

These twin daguerreotype portraits from the mid-19th century are of Willis E. and Mary Bradley Miller. Miller worked his way up to the presidency of the axle works at the head of the Sleeping Giant. He became involved in an array of benevolent and civic enterprises. Following his death, his wife donated a substantial sum toward the creation of a town library. It is for him that Hamden's main library is named.

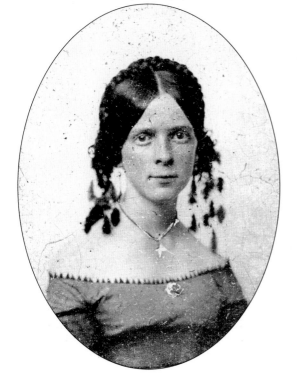

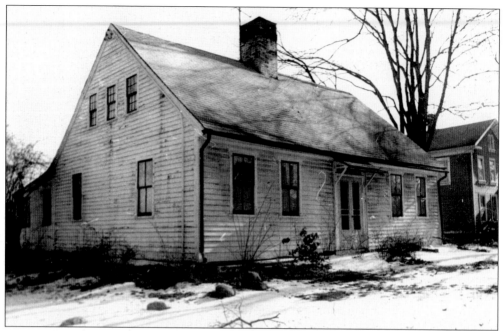

The Miller homestead was built on Whitney Avenue by Chauncey Miller *c.* 1785. Willis E. Miller lived here until his marriage. The house was demolished in 1980.

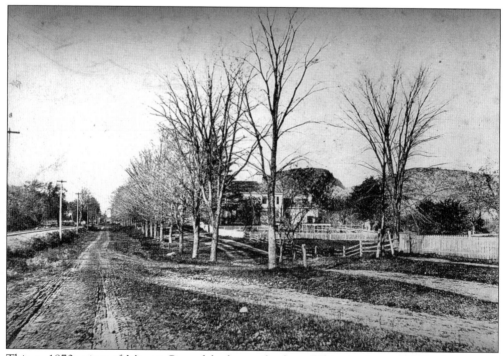

This *c.* 1870s view of Mount Carmel looks north along Whitney Avenue from the current location of St. Mary's Cemetery. The Sleeping Giant can be seen in the background.

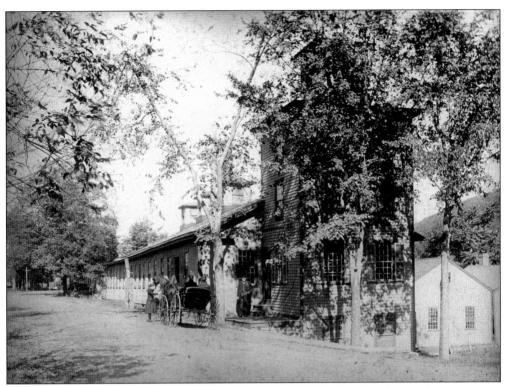

The lower shop of the Mount Carmel Axle Works was part of a complex that made components for New Haven's carriage industry.

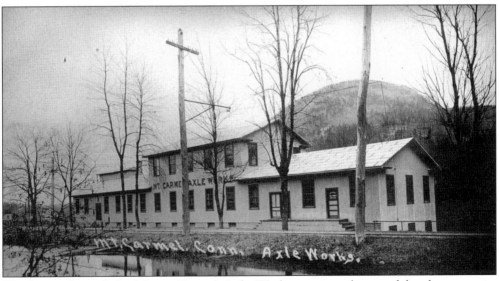

The lower shop of the Mount Carmel Axle Works was complemented by the upper, or finishing, shop.

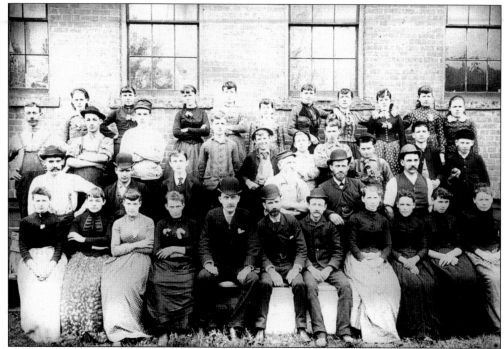

Employees of the Mount Carmel Bolt Shop pose for a picture, probably in the late 19th century. They include a mix of male and female adult workers, as well as children.

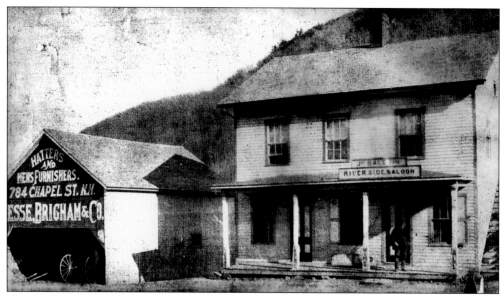

The Baldwin Riverside Saloon, located near the Sleeping Giant, was patronized by the male workers of the mills and factories nearby.

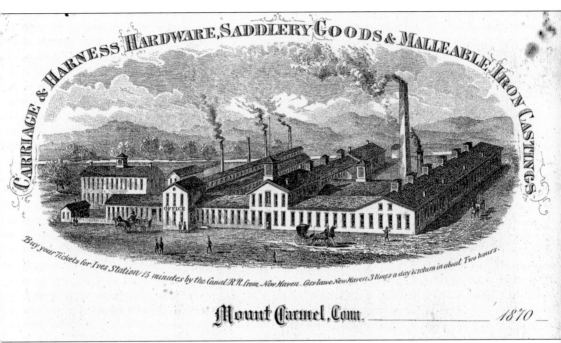

This image reproduces a piece of letterhead showing the Ives and Granniss carriage and harness hardware factory.

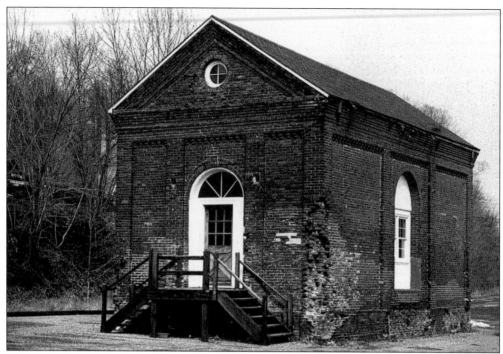

The Mount Carmel freight station was built in 1883. Today, the structure houses a private business.

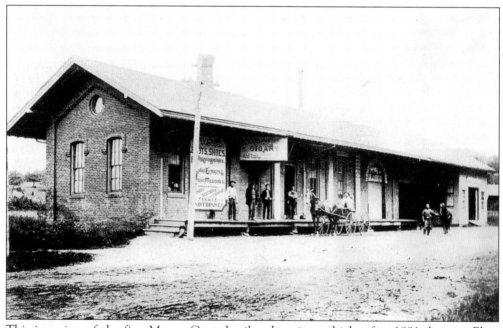

This is a view of the first Mount Carmel railroad station, which, after 1881, became Elam Dickerman's Depot Store, pictured here in 1889. The station stood on the west side of Whitney Avenue between the Mount Carmel Congregational Church and the Young Ladies' Seminary (currently 3220 Whitney Avenue). (Gift of Dr. George Joslin.)

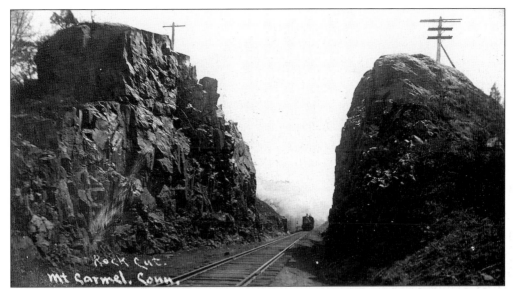

A significant geological formation in Mount Carmel was the Steps, a rising shelf of rock that made travel very difficult. As the area was settled, more and more of the rock was removed, as seen in this photograph of a railroad cut through the Steps at Mount Carmel. Today, only a small remnant of the formation can be seen along the west side of Whitney Avenue opposite Mount Carmel Avenue.

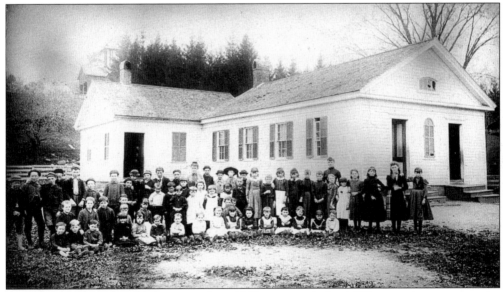

The Mount Carmel School, pictured c. 1890, once stood on Whitney Avenue opposite Ives Street.

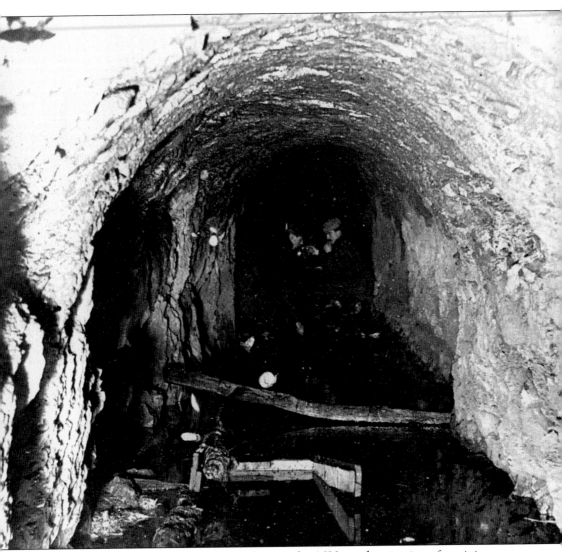

From the settlement of New Haven Colony in the 1630s to the creation of a mining company by John Davenport and Theophilus Eaton, there have been numerous efforts to find mineral wealth in the Hamden area. This picture, probably from the late 19th century, shows two men exploring the shaft dug during the late 18th century at what is called Tall Man's Mine. Actually, the mine is named for David Tallman, who extracted copper from what is now known as Ridge Hill, north of River Road in the far northern part of Hamden near the Mill River. Local tradition has it that the mine yielded enough to make Tallman considerably wealthy. However, not enough ore was found to sustain the expenses of the mine. Mount Carmel even had its own version of the Gold Rush of 1849, when—no doubt to the amusement of locals—speculators from out of state leased land in the Ridge Hills and surrounding areas to search for ore.

Looking south on Whitney Avenue, this *c.* 1885 view shows the homes of Dana Cooper and J. A. Granniss (left) and the factory used by the Goodyear Company to make sewing machine parts (right).

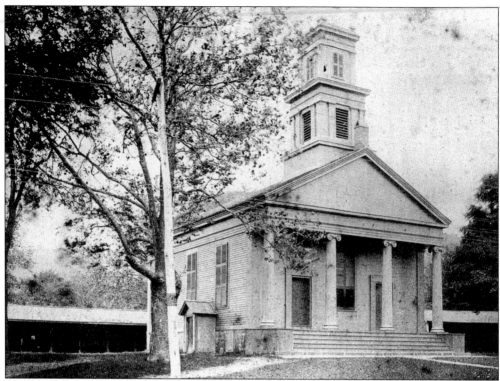

The Mount Carmel Congregational Church is pictured sometime in the late 19th century, with horse sheds in the back for quartering teams and carriages during services.

The Mount Carmel Congregational Church choir poses for a portrait on the steps of the church c. 1885. Members are, from left to right, as follows: (front row) Dana Cooper, Nellie Ives, Jennie Higgins, Kate Ives, and Frank Pierce (organist); (middle row) Mrs. Frank Pierce, Adelia Ives, and Jesses Jacobs; (back row) Lyman Bassett, Howard Doolittle, Newell Edgerton (organ pumper), and Wilbur Ives.

This is a group photograph of Emma Dickerman's Sunday school class in 1893. From left to right are the following: (seated) Ben Munson, Bill Hitchcock, Newell Edgerton, Herbert Dickerman, Leon Peck, and Chauncey Ives; (standing) Ben Dickerman, Warren Doolittle, James Doolittle, Sherwood Doolittle, Leon Fowler, and Fred Thorpe. (Courtesy Miriam, Alice, and Leon Peck.)

The Mount Carmel Congregational Church also sponsored a boys' brigade, which is pictured c. 1897. From left to right are the following: (first row) Wesley Peck, Wilbur Ives (captain), DeForest Bailey, Clifford Johnson, and Charles Cooper; (second row) William Trappe, Carl Sheldrick, and Theodore Vick; (third row) Frank Loomis, John Dicks, Clifford Andrews, Frank Swain, and Rupert Edgerton; (fourth row) Orrin Dickerman, Fred Crump, James Strain, Herbert Dicks, Thomas Miller, William Ives, Herbert Crump, and Joseph Miller.

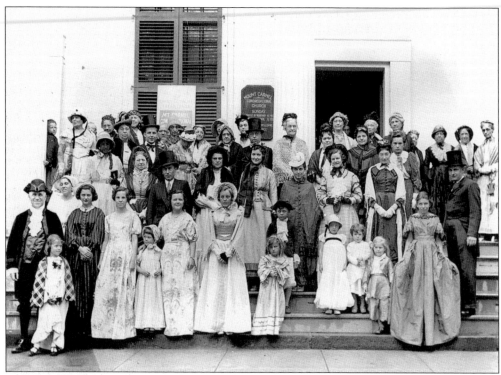

In period garb, members of the Mount Carmel Congregational Church observe Connecticut's tercentenary in 1936. (Photograph by I. A. Sneiderman.)

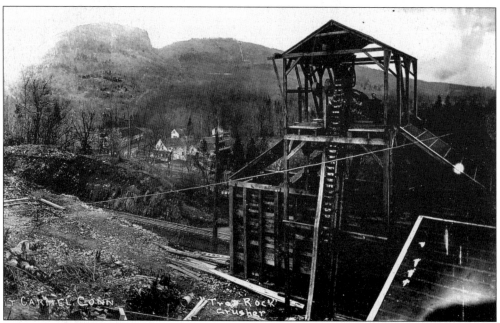

The traprock crusher operated along the railroad cut overlooking the Sleeping Giant. Traprock was quarried from the head of the Sleeping Giant during the late 19th and early 20th centuries and was used for gravel.

This edifice was used by the Church of Our Lady of Mount Carmel from 1856 to 1891.

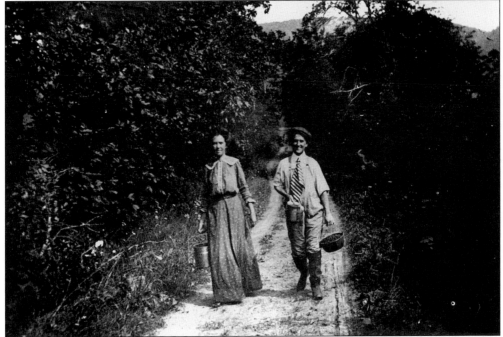

Mrs. Charles Lincoln (left) and Mrs. Walter Greist go blackberry picking on Ridge Road c. 1905. (Nancy Sachse papers.)

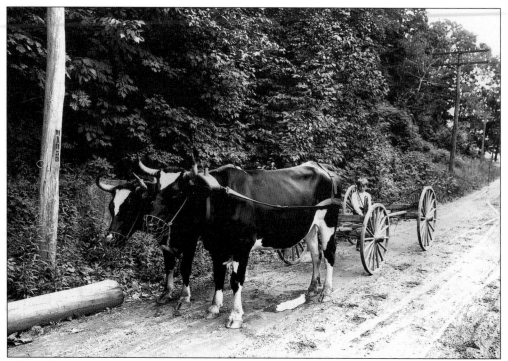

The 19th century meets the 20th century: a boy drives a team of oxen, probably in the Mount Carmel area, *c.* 1900 (above), and the Fitch Brothers' gas station on Whitney Avenue in Mount Carmel advertises gasoline for 16¢ a gallon. (Above, courtesy H. B. Welch collection.)

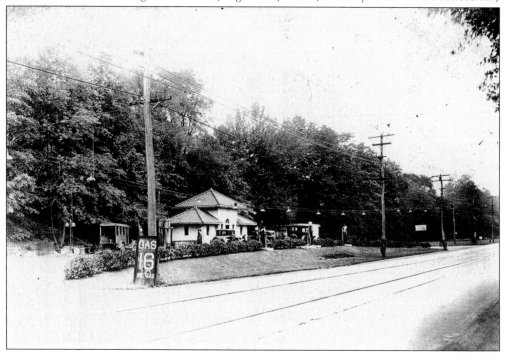

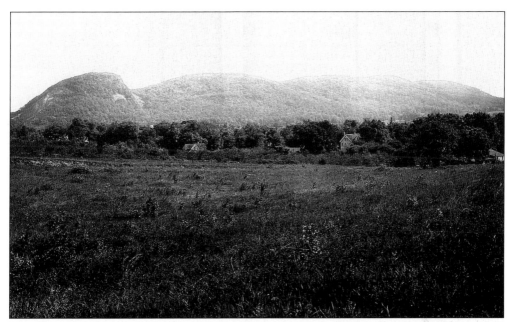

The Sleeping Giant is viewed from the southwest at a time when the area was still very rural. Known alternately as the Blue Hills, the more biblical Mount Carmel, and the Sleeping Giant, the series of five hills is 2 miles long and 796 feet at its highest point.

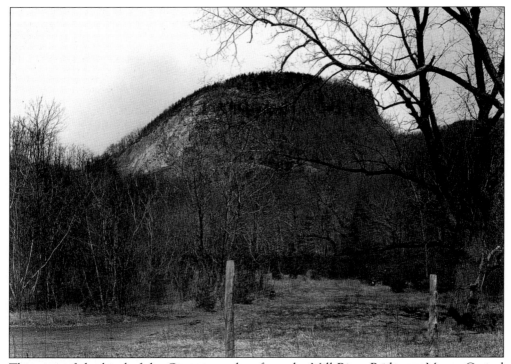

This view of the head of the Giant was taken from the Mill River Bridge on Mount Carmel Avenue. (Photograph by Arthur J. Tefft.)

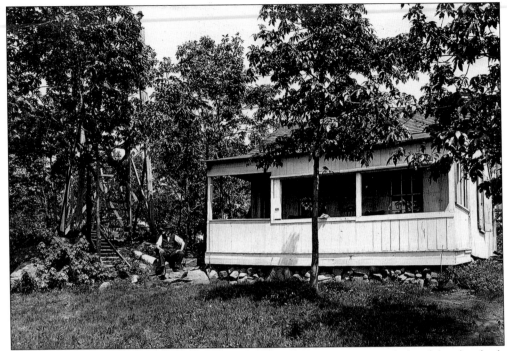

Before the area including the Sleeping Giant was turned into a state park, local families built summer houses on the peaks. This is the Brockett cottage, on the third mountain.

The Sleeping Giant is portrayed in this early-20th-century photograph. The 1792 Jonathan Dickerman II house (left) stands in its old location, on the north side of Mount Carmel

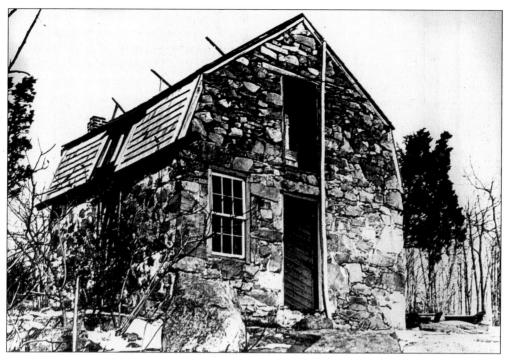

The Stone house stands on the fourth mountain of the Sleeping Giant. (Photograph by H. B. Welch, courtesy G. H. Welch.)

Avenue. Moved to the south side in 1963, the house became the property of the Hamden Historical Society.

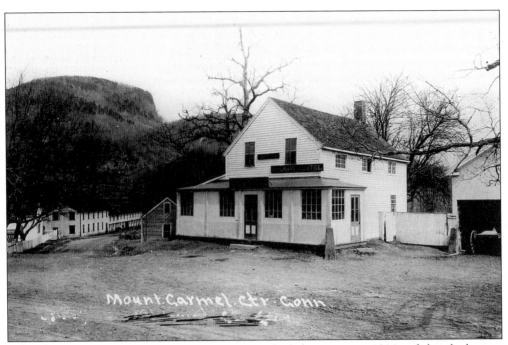

The store at the Steps was owned by Roderick Kimberly beginning in 1814 and then by his son Hobart Kimberly. It was near the lower works of the Mount Carmel Axel Shop (left).

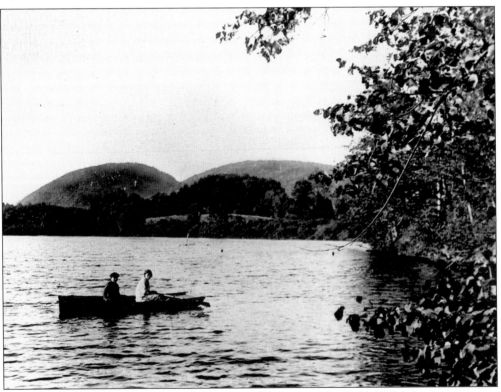

Boating on Clark's Pond was a popular pastime. (Photograph by H. B. Welch.)

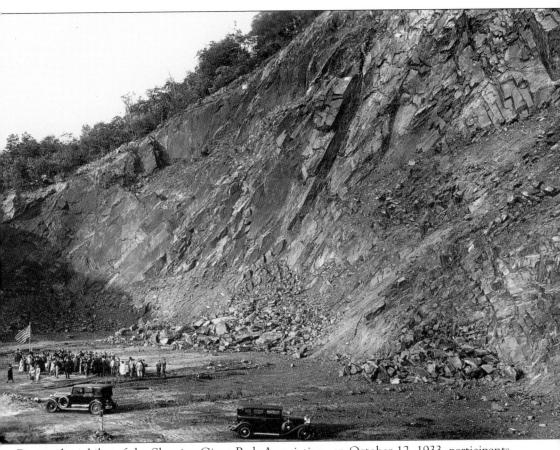

During the jubilee of the Sleeping Giant Park Association, on October 12, 1933, participants view the damage done to the Giant's head by traprock quarrying. One of the agreements with the mining company was that the quarry not be visible from Mount Carmel Avenue. The white squares painted on the rock show how the company transgressed the terms of the lease, contributing to efforts to save the Giant by turning it into a state park.

On October 12, 1933, members and supporters of the Sleeping Giant Park Association celebrated the last great purchase of land known as the Head of the Giant and, more importantly, the closing of the traprock quarry located at the Giant's chin and skull. These early enthusiasts fought and finally prevailed in saving this magnificent natural attraction for all future generations to enjoy. The land acquisition effort began in 1924 and continues today, with more than 1,700 acres deeded for state recreational use.

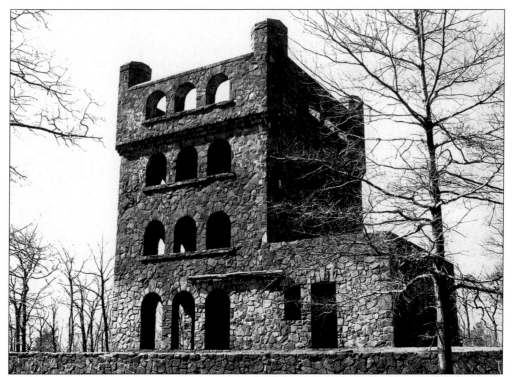

The stone viewing tower was built atop the Sleeping Giant, using materials salvaged from the old cottages.

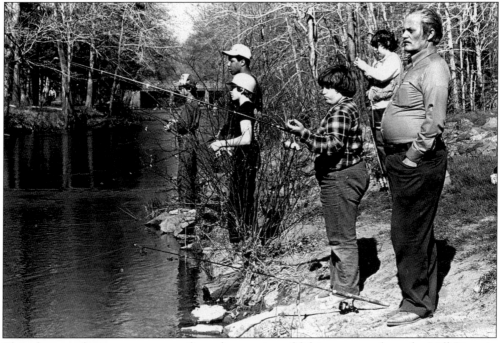

This photograph preserves a scene from the opening of fishing season along the Mill River in Sleeping Giant State Park in 1979. (Photograph by Lee Robinson.)

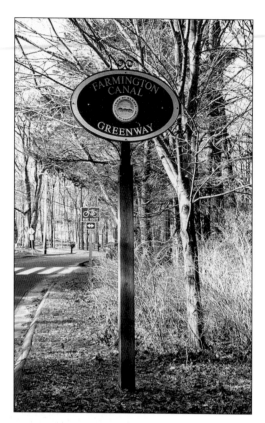

The Farmington Canal Trail, which runs along the former canal from New Haven to Northampton, Massachusetts, operated from 1825 to 1849. After the canal closed, a railroad line was put on the towpath. The linear park was opened in the 1980s and is used by thousands of bikers, hikers, and rollerbladers every year.

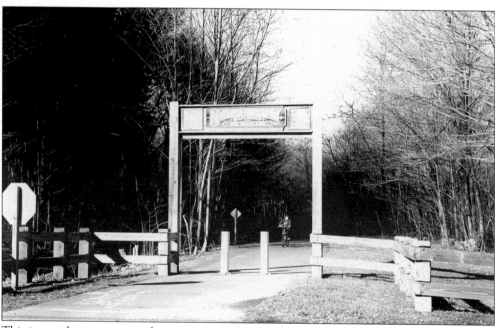

This image shows a present-day entrance to the Farmington Canal Trail in upper Hamden.

Eight
CENTERVILLE

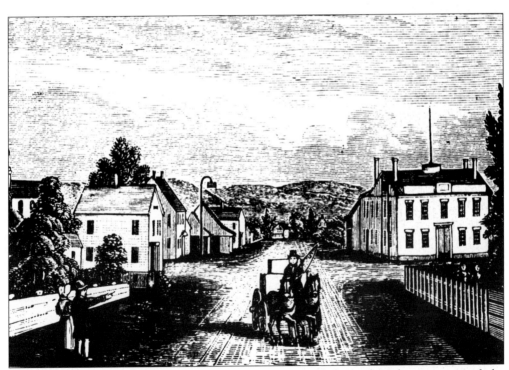

This engraving, entitled the *Central Part of Hamden*, is the earliest known view of the Centerville crossroads. It is from John Barber's *Connecticut Historical Collections* (1836) and shows the Grace Episcopal Church (left), the Old Tavern (northwest corner) operated by Jesse Goodyear, and the new Centerville Hotel (right), erected in 1836.

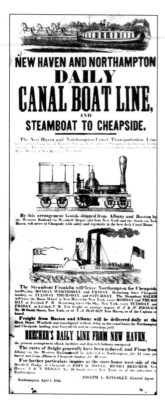

A broadside of 1845 advertises the New Haven and Northampton Daily Canal Boat Line. The Farmington Canal, built in the late 1820s and running through Hamden, opened the town to regional markets and, via steamer, to New York City.

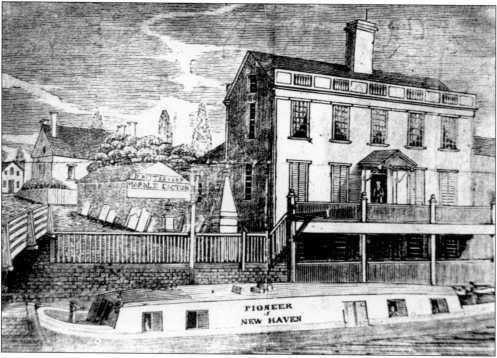

An engraving of a scene on the Farmington Canal in the early 19th century depicts the type of canal boat that regularly made trips through Hamden on its way north and south.

The Rectory School, on Whitney Avenue, was founded in 1843 as a private military school for boys by Rev. C. W. Everest, rector of Grace Episcopal Church. For more than 25 years, the Rectory School was a leading military boarding school in America. At its height in 1853, it had a maximum enrollment of 65 students from many states in the Northeast and South. Everest and six assistants instructed the students throughout the first years. Eventually, Maj. James Quinn and Col. John Arnold were hired as instructors in military tactics. During the Civil War and beyond, the school graduated hundreds of students who became successful businessmen, military officers, and members of Congress.

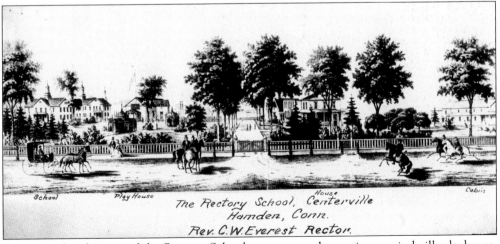

Shown in this drawing of the Rectory School campus are the seminary, windmill, playhouse, gashouse, boathouse, and barn. (Photograph by Bernard S. Budge.)

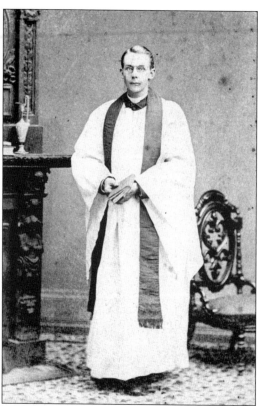

This 1864 portrait is of Rev. C. W. Everest, founder of the Rectory School. Everest ran the school until 1870, and his sons reopened the establishment in New Milford in 1885.

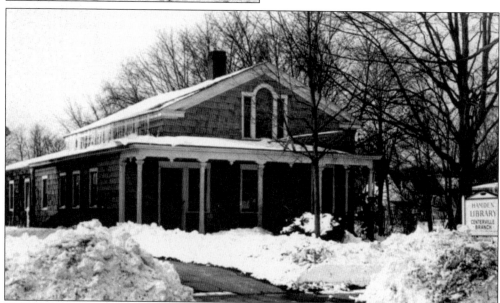

In 1861, the cabin of the Rectory School, at 2324 Whitney Avenue, became the home of the school's rector, C.W. Everest. However, the building lived on to serve other uses: in the 1920s, it housed the first telephone exchange in Hamden, and in 1931, it became the Hamden Public Library. The privately funded library became part of the town's public library system when it was established in 1943. The Centerville branch remained here until 1952.

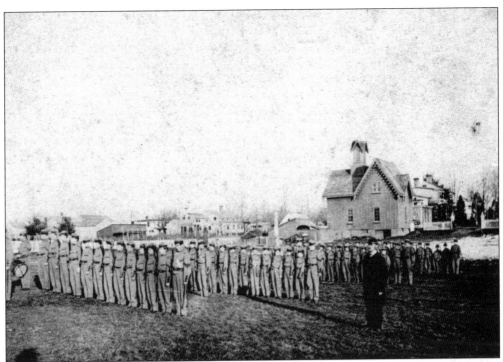

This stereograph image shows students of the Rectory School on parade. The undated picture may have been taken as early as the mid-19th century.

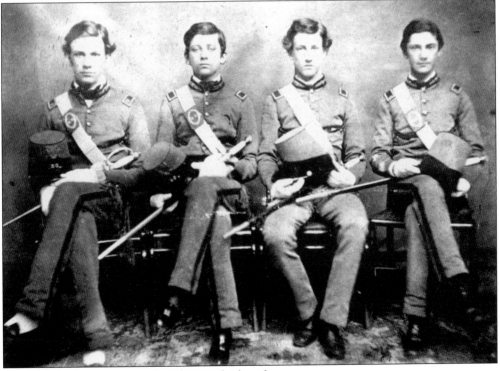

Rectory School students pose in the standard uniform.

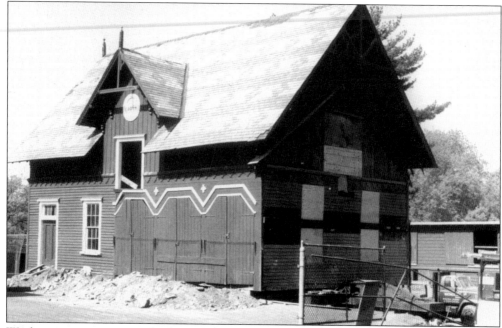

Workers prepare to move the historic rectory barn in 2001. The original structure, built in 1844, was burned by a disgruntled student. The present structure, designed by Henry Austin, dates from 1869. Spearheaded by the Hamden Historical Society, the campaign to save the historic structure involved the cooperation of many individuals and agencies. (Photograph by Al Gorman.)

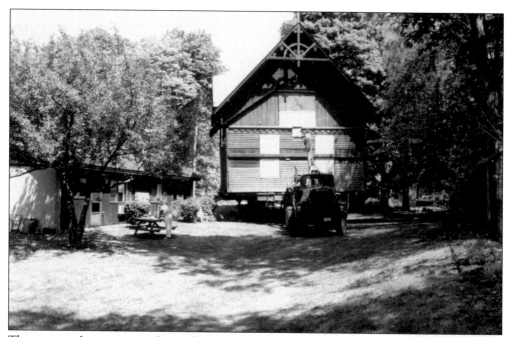

The rectory barn is moved via flatbed trailer to its new location on Dixwell Avenue. (Photograph by Al Gorman.)

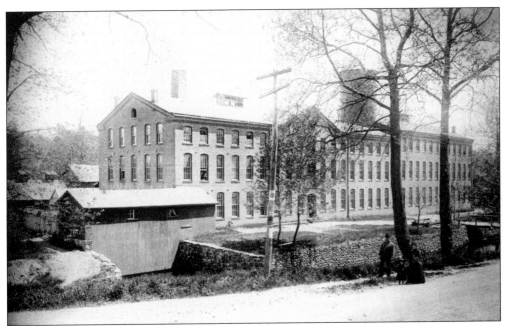

The New Haven Web Company building was once located where the Wilbur Cross Parkway now crosses Whitney Avenue. Principally a factory for elastic and nonelastic webbing, the company produced cartridge and machine-gun belting and straps for gas masks during World War I.

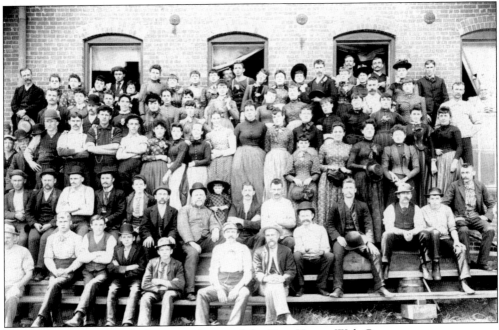

This undated photograph shows employees of the New Haven Web Company.

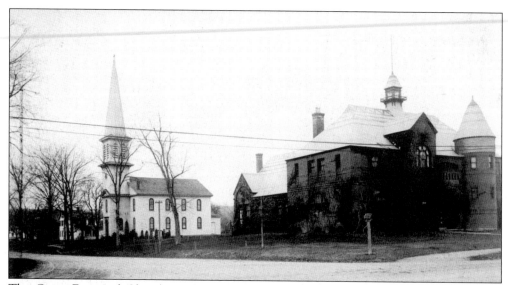

The Grace Episcopal Church stands in its original location, on the north side of Dixwell Avenue. Beside it is Hamden's first town hall, built in 1888. The church was moved to its present site, on the south side of Dixwell, in 1929.

Pictured is the house of Leverett H. Candee, located at the southeast corner of Dixwell and Whitney Avenues. Candee obtained a license to use Charles Goodyear's process for making rubber shoes and built a factory in Centerville, later the site of the New Haven Web Factory. The Candee house, which became Hamden Medical Services, was demolished in 1981 to make way for an office and retail complex.

108

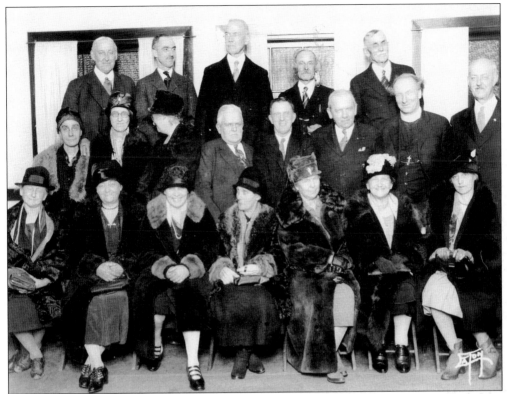

The Hamden Civic Association, shown c. 1912, was one of the first organizations of its kind in town. It was created in an attempt to unite Hamden's disparate communities. From left to right are the following: (front row) Helen Porter, Elizabeth Hooter, Gladys Crook, Alice Remer, Evangeline Bassett, Mrs. A. J. Ralph, and Ella Bassett; (middle row) Alice Warner, unidentified, Jennie Ives, Burton Potter, Floyd A. Beecher, Roger Bacon, Rev. George Cooley, and William Hevis; (back row) Ellsworth Warner, Waiter Bassett, Rev. W. G. Lathrop, A. J. Ralph, and Manley Chester.

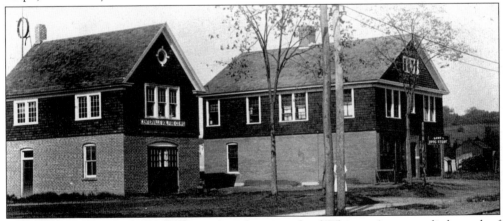

The old Centerville firehouse (left) stood on the west side of Whitney Avenue, a little south of School Street. It was built on town hall property in 1908, four years after the organization of the Centerville Volunteer Fire Company. The original equipment consisted of hatchets, helmets, and a hose on a two-wheel reel. Rowe's Drug Store was located in the building next door.

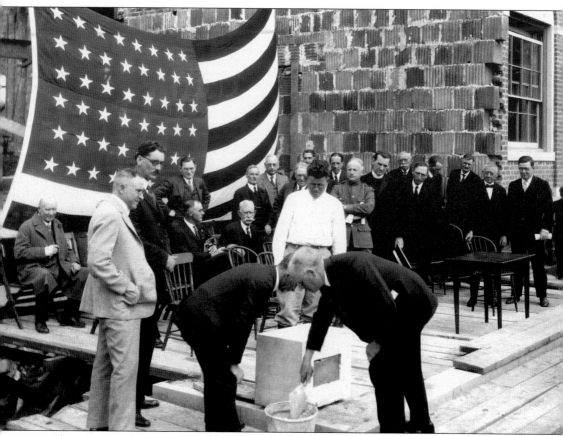

This photograph preserves a moment in the laying of the cornerstone of the new town hall in 1924.

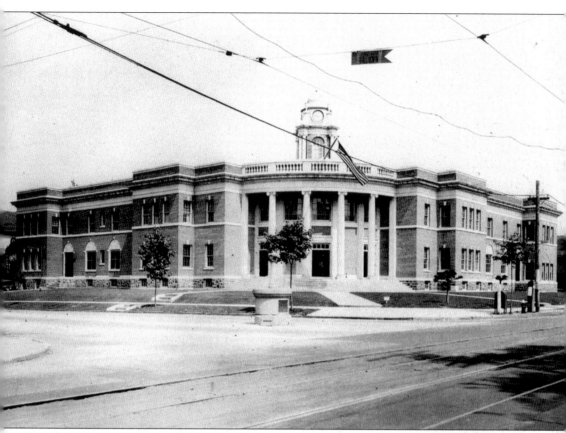

Hamden Memorial Town Hall was designed by architect and Hamden resident Richard Williams. The structure, recently listed on the National Register of Historic Places, features a semielliptical colonnade as an entrance. It was constructed at a time when Hamden was evolving from a patchwork of small rural communities (note the horse trough in front) to a modern suburban town (note the trolley tracks and wires). The town hall's rotunda is a memorial to Hamden veterans in eight wars.

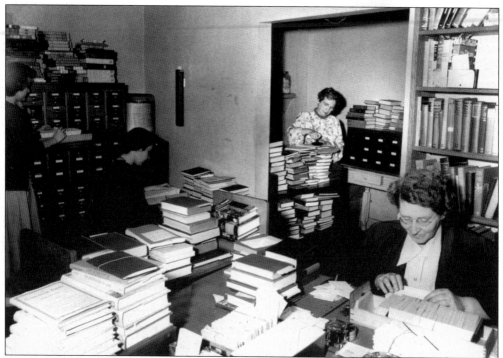

The staff of the Hamden Public Library, seen here in 1931, labors in the rather cramped quarters of the former Rectory School cabin on Whitney Avenue.

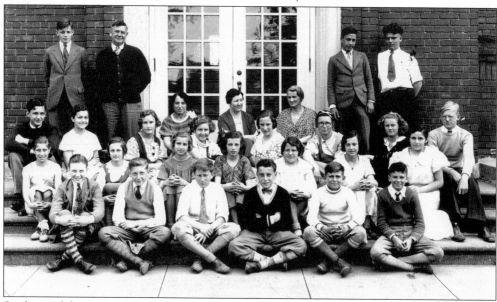

Students of the Centerville School in 1933 included Eula Aagliaterri, James Abbatillo, Annie Armistead, Lucien Cardinal, Coriena Cassari, Rose M. Cavalieri, Emery Felan, Joseph Gente, Shirley Hine, Nullo A. Malivasi, Margaret McVerry, Ottello Massoni, Mary S. North, Dick Olson, Carl Peterson, Dorothy M. Picagli, Elia Platino, Edward Renaldi, Louise Ruth, Tillie G. Santillo, Vera Sherry, Verna Schulze, Olive H. Smith, William Somers, Robert B. Vining, and Shirley Ann Visel. (Gift of Verna Schulze Nedovich.)

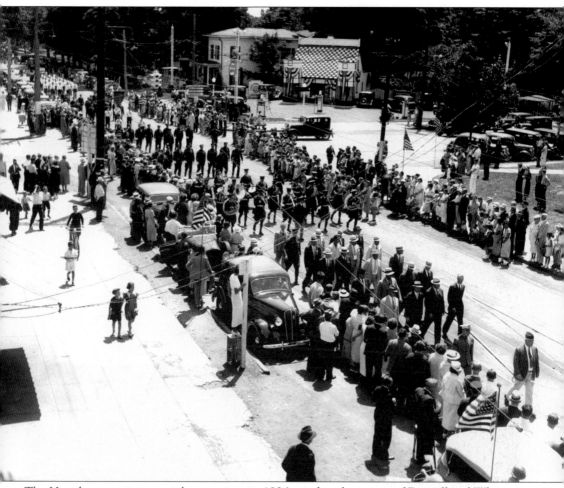

The Hamden sesquicentennial procession, in 1936, reaches the corner of Dixwell and Whitney Avenues. (Raymond Rochford scrapbook.)

This photograph preserves another scene from the sesquicentennial procession in 1936. (Raymond Rochford scrapbook.)

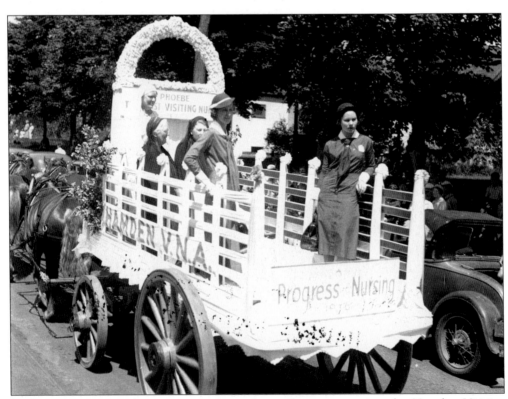

In the sesquicentennial procession, a horse-drawn float representing the Hamden Visiting Nurses Association celebrates the "Progress of Nursing." (Raymond Rochford scrapbook.)

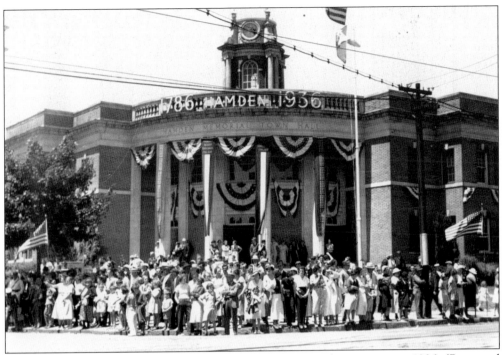

Spectators in front of town hall wait for the sesquicentennial procession in 1936. (Raymond Rochford scrapbook.)

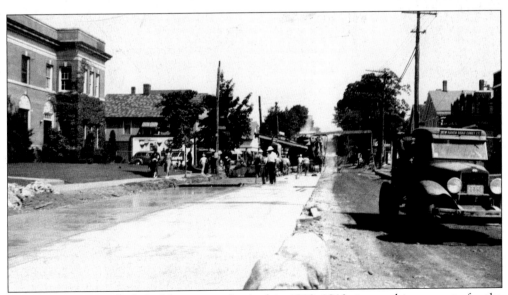

Whitney Avenue, which had been macadamized in 1912–1913, is paved in concrete for the first time. The trolley tracks were removed in 1937–1938.

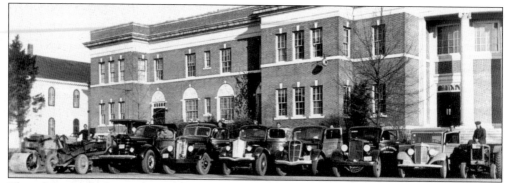

This photograph shows the public works department vehicles parked in front of town hall in 1934.

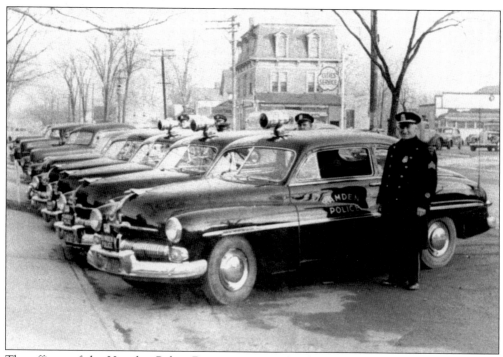

The officers of the Hamden Police Department pose by their squad cars in the 1950s. Before the 1920s, Hamden was protected by haywards, or constables. It was not until 1923 that the modern police force was founded. The department was first housed in the basement of the town hall, and a separate building was constructed in 1952.

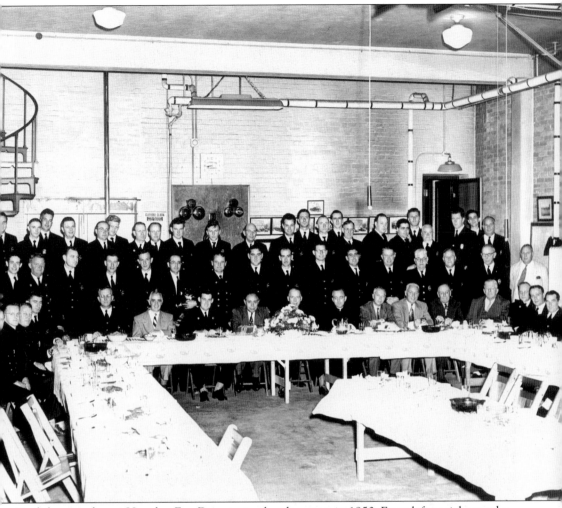

Firefighters gather at Hamden Fire Department headquarters in 1950. From left to right are the following: (front row) C. Wetmore, H. Hurlburt Sr., D. Hume, P. Rosadina, W. Baker, unidentified, P. Leddy, Rev. J. Peters, Chief R. C. Spencer, two unidentified men, H. Hume, unidentified, A. Ruwett, E. Strain, R. Carofano, W. Thomas, and L. Tobin; (middle row) J. Strain, R. Vreeland, F. Leddy, E. Doherty, B. Hillocks, W. Hines, F. Eitler, M. Serafino, J. Hromadka, R. O'Donnell, W. Bossoli, G. Reutenauer, V. Roth, J. Hoffman, J. Dukat, unidentified, R. Reutenauer, and A. Purce; (back row) E. Bevins, R. Norman, J. McKee, A. Smith, L. Bellemore, S. Trower, R. Williams, R. Ruwett, D. Hermann, D. Howe, J. Laffin, F. Nolan, A. Ramelli, K. Harrington, W. Blake, T. Cummins, R. Rosson, F. Fletcher, S. Ferraro, H. McLean, C. Kammerer, D. O'Connell, R. Lostritto, and J. Norman. (Photograph by Lewis R. Berlepsch.)

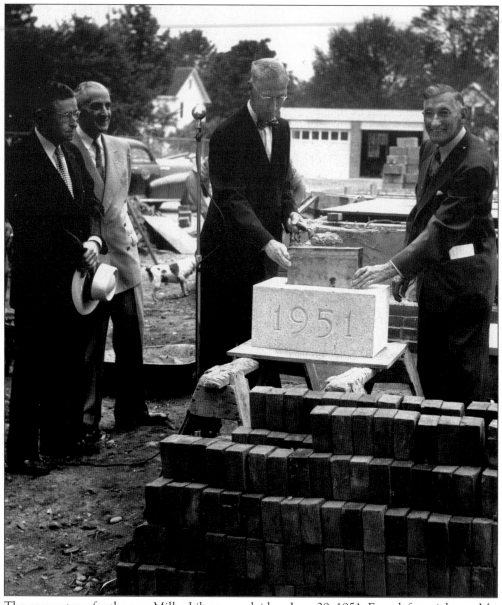

The cornerstone for the new Miller Library was laid on June 29, 1951. From left to right are Mr. Whalen, Mr. Connelly, Mr. Miller, and Mr. Pelton.

The Miller Library building is pictured in 1952, shortly after its completion. Later, when the new Miller Library was built across the street, this structure became police headquarters. (Photograph by Thomas Pool.)

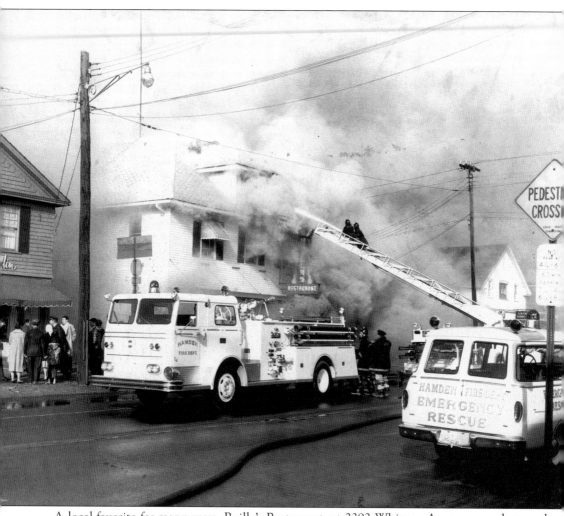

A local favorite for many years, Reilly's Restaurant, at 2392 Whitney Avenue, was destroyed by fire on Christmas Day 1964, which was an unseasonably mild day. (Gift of David Johnson.)

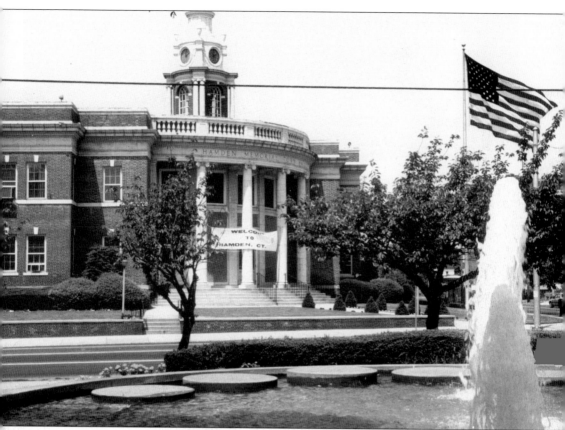

This 1970s view of Hamden Memorial Town Hall includes the fountain across the street. (Photograph by Lee Robinson.)

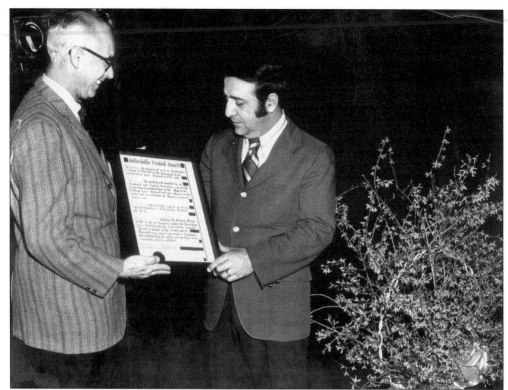

Jazz artists Dominick and Samuel Costanzo were honored for their role in the Hamden Goldenbells Festival in 1972. Pictured are Christian Rendeiro (left) and Sonny Costanzo.

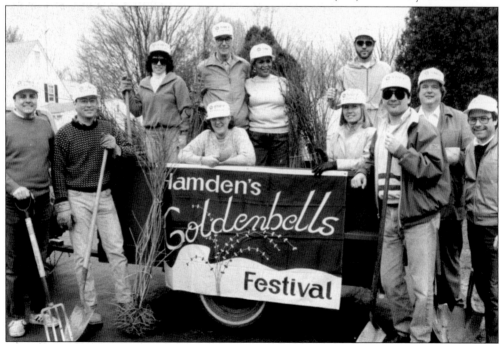

Shown are some participants in the 1989 Hamden Goldenbells Festival.

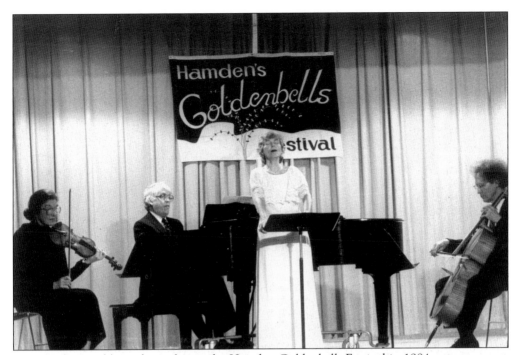

A musical ensemble performs during the Hamden Goldenbells Festival in 1984.

Mayor Lucien
De Meo speaks at
Hamden's celebration
of the United States
bicentennial in 1976.
(Photograph by
Peter R. Hvizdak.)

This 1976 photograph is of Christian Rendeiro, founder and director for 25 years of the Hamden Goldenbells Festival, and his wife, Pamela Rendeiro, dressed in period costume for the festival ball.

Representing the Hamden Historical Society at the 1976 Hamden Goldenbells Festival Human Services Fair, from left to right, are Barbara Doheny, Gretchen Zukunft, Virginia Zukunft, and John Carusone.

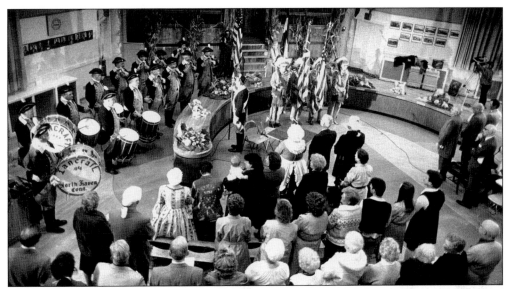

A fife-and-drum band processed into the legislative council chamber during a bicentennial ceremony in 1976.

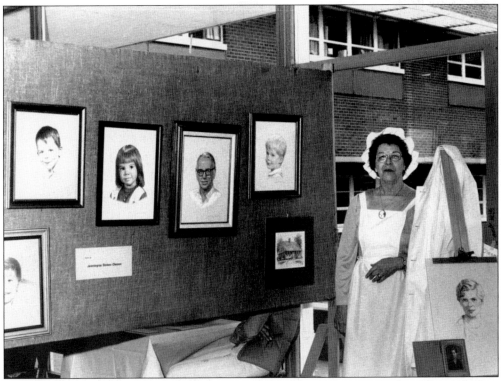

Portrait painter, artist, and Hamden High School teacher Jeaniegray Stokes Olesen displays some of her work at an April 1976 exhibition for the Goldenbells Festival as part of America's bicentennial celebration. Shown are family portraits of Geoffrey Johnson, David Johnson, Sandra Johnson, William Howard Olesen, and Michael Rider Jr.; a 1970 drawing of the Jonathan Dickerman house; and an unfinished portrait of Edna Vick, the artist's sister.

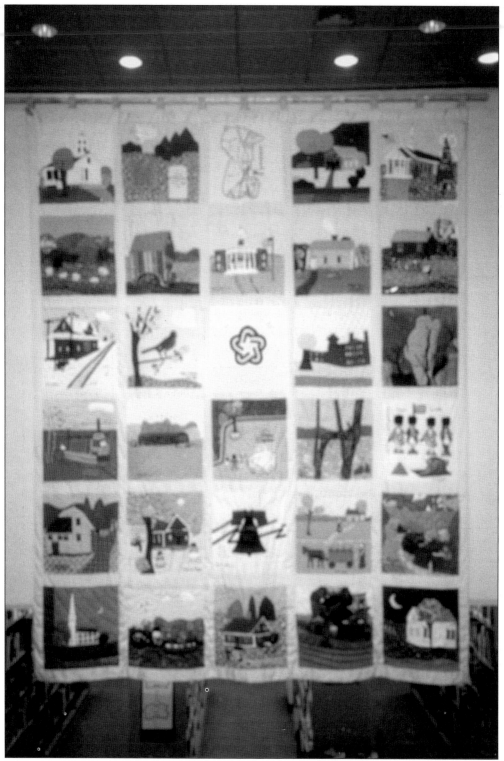

This 1975 photograph portrays the bicentennial quilt made by the Mount Carmel Quilters.

The Mt. Carmel Quilters, who are the outgrowth of a Ten-Week Adult Education Course, offered by the Town of Hamden, held at the Mt. Carmel Library, have, under the direction of Anne Johnson, Instructor and Barbara Fitzsimons, Chairperson, created this

MT. CARMEL QUILTERS - BI-CENTENNIAL QUILT

Quilters range in ages from about 20 to 80. There are many original creations.

All Sewing and Quilting is done "BY HAND"

Mt. Carmel Cong. Church Joyce Tomlinson **	Cemetery Plot Gertrude Perrigo	Map Hamden Mildred Pardee * **	Eli Whitney Block House Gertrude Perrigo	Church of Our Lady of Mt. Carmel Sister Mary Ambrose **
Sleeping Giant Mary Putman *	Beer's Grist Mill Anne Johnson	Town Hall Barbara Fitzsimons **	Toll House Lois Beardsley *	Saw Mill Margaret Gilbert
Mt. Carmel R. R. Station Alice Connell	Peter's Orchards Reta Eber	Bi-Centennial Emblem Mildred Engelhardt *	Webb Shop Gail Paulson	Leatherman's Cave "The Brethren" Nancy Bergantino *
Trolley Car Dorothy Egan **	Covered Bridge Betty De Almo * **	Freedom Park Phyllis Mc Henry	Door Tree Mildred Pardee * **	Foot Guards Patricia Trickey
Eli Whitney Barn Nan Gilmond	West Wood School Helen Barnard & Reta Eber * **	Liberty Bell Jane Harman	Milk Wagon Margaret Michener	Ice House Lake Whitney Una Fowler *
Grace Episcopal Church Elsa Rasche	Canal Boat Katherine Nolan	Jonathan Dickerman House Dorothy Poletti * **	Centerville Drug Store Peg Bergantino	Hamden Plains Meth. Church Jean Eliott

* Pictured in Rachel Hartley's "History of Hamden" Started April 8, 1975
** Sketched by Curtis Pardee Completed July 3, 1975

We have all had fun and are proud of our accomplishment

This plan shows the theme and name of the quilter of each square in the bicentennial quilt.

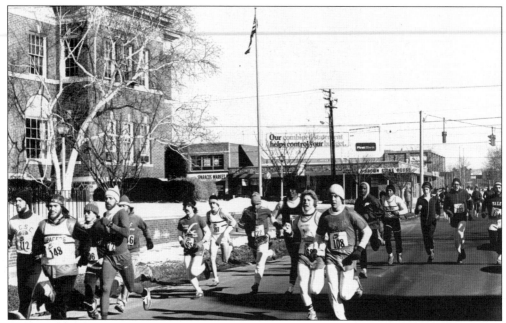

The Elks Road Race passes town hall on February 11, 1979. (Photograph by Lee Robinson.)

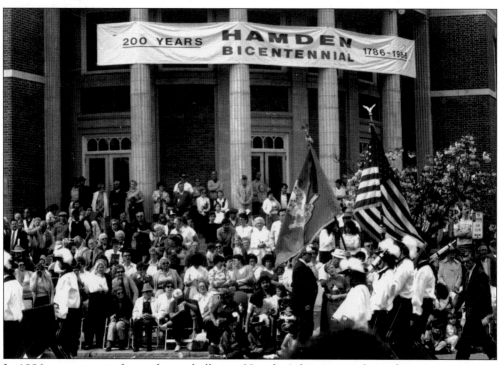

In 1986, spectators in front of town hall view Hamden's bicentennial parade.